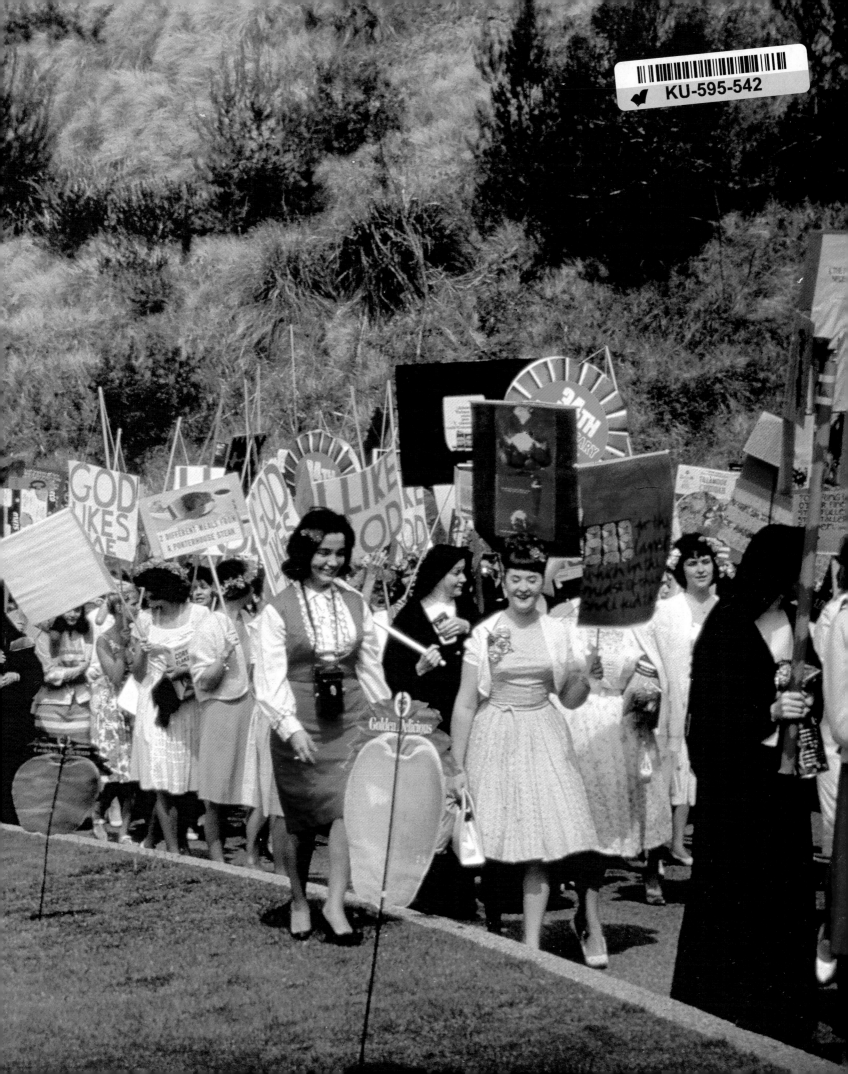

Come Alive! The Spirited Art of Sister Corita

Julie Ault

Four Corners Books

IT SE

EVER ME

BEAUTIF

LIKE MA

G, AND T

IDE HUA

Published by
Four Corners Books
37 Tite Street
London SW3 4JP
www.fourcornersbooks.co.uk

Front cover, back cover, p.1,
details, *jesus never fails*, 1967;
p.2, detail, *with love to the
everyday miracle*, 1967; p.3,
detail, *Mary's Day*, 1964; p.6,
exhibition of Corita prints,
1966; p.7, detail, *bread
breaking*, 1965; p.8, detail,
now you can, 1966; p.118,
Corita with billboard she
designed for the Physicians
for Social Responsibility,
San Luis Obispo, 1984; p.126,
detail, *Survival With Style*, 1966.

Distributed in Europe by
art data www.artdata.co.uk and
in North America by D.A.P./
Distributed Art Publishers
www.artbook.com
Designed by Nick Bell Design
www.nickbelldesign.co.uk
Printed and bound by
Balding+Mansell
www.saxongroup.com
Printing production by
Martin Lee

ISBN-13: 978-0-9545025-2-2
ISBN-10: 0-9545025-2-3

The Spirited Art of Sister Corita
by Julie Ault

In August of 1968 Sister Corita made a bold move, surprising everyone, apparently even herself.[1] While on sabbatical from her position as chair of the art department at the Immaculate Heart College, after two months of staying with her friend Celia Hubbard in Massachusetts, she announced she was leaving Los Angeles, her life there, and her religious community altogether. She did not offer much explanation, at least not to the press: "My reasons are very personal and very hard to explain. It seems to be the right thing for me to do now."[2]

Immaculate Heart

What exactly was Corita leaving? She was parting from the sisterhood and the religious order that provided the spiritual, living, and working structure of her adult life as well as the vows that compose a sister's life – obedience, celibacy, and poverty. The cloistered, collective environment of the Immaculate Heart Community, in which Corita had lived since 1936, from the age of eighteen, was a singular milieu – renowned for its liberal orientation that she had helped generate. That community had in turn nurtured the prominent "modern nun,"[3] and radically influenced the path of her art.

Corita was also leaving the Immaculate Heart College, where she taught for over twenty years and headed its art department during the last four. Since the 1950s the college had been both celebrated and criticized for its progressive educative environment. By the 1960s, the college's art department had become legendary – characterized as inspirational not only by Catholics and students, but by illustrious figures including Buckminster Fuller, who declared, "Amongst the most fundamentally inspiring experiences of my life have been my visits to the art department at Immaculate Heart College." Charles and Ray Eames, other luminary supporters, whom Corita counted as primary influences on her creative process, teaching, and art making, opened their house and studio to the sisters and their students annually in the 1950s and 1960s. Both Fuller and Charles Eames had participated in the Great Men lecture series that long-time art department chair Sister Magdalen Mary initiated and which Corita directed for some years. The series included James Elliot, Leonard Stein, John Cage, Alfred Hitchcock, Saul Bass, Herbert Bayer, Jean Renoir, and Virgil Thomson.[4] Today, this list reads like a cultural who's who, but at the time they were

← Left to right: IHC student, IHC teacher Sister Helen Cary and Corita, Mary's Day, 1964
↙ Buckminster Fuller visiting the IHC art department, with Corita

fairly accessible: Corita organized the lectures by simply writing to these men, inviting them to visit and talk about their lives, their thinking and working methods, and engage in Q&A with the students.[5]

Corita's celebrity seemed to run on a parallel track with the college's. "Many nuns are caught between the traditional idea that they should be humble and not exalt their work and a contemporary culture that elevates the cult of the individual."[6] Some say Corita was similarly conflicted, at least in the early years of her career, before she gained self-confidence.[7] However, judging by contemporary accounts, she was not the kind of person to suppress the fullness of her character for long, or to marginalize her ideas – certainly not for the sake of adhering to traditions she found problematic. Corita was charismatic and she was fearless. She spoke and acted with conviction and verve, exuding good energy as she beckoned people to graciously sidestep oppressive cultural conventions in favor of a celebrational (perhaps subversive) interrogation of society through creativity and everyday actions. Likewise, her art was bold and aesthetically joyful in its offering of spiritual renewal, social critique, and political efficacy. The mix of disarming personality and daring art brought Corita into the public eye, and kept her in demand in the college, in Catholic communities, and in both local and national press.[8] Barbara Loste claims, "By the mid-1960s, as a result of her growing recognition as an artist and teacher, Sister Corita began to experience

almost rock-star status among her students and some art collectors."[9] Speaking about how fame affected her classroom, Corita explained:

I was a big old taskmaster and gave fantastic assignments. I don't suppose they ever screamed at me but they'd complain lots. One of the reasons I stopped teaching, I say it laughingly, was that I became a kind of celebrity and it started getting in the way. There would be visitors, very well intentioned, who just wanted to meet me – this sort of thing. Some of this was interesting because it brought interesting projects for the students to work on…But I think the students resented my fame because whenever they would do something they would be labeled as my students. I didn't give two hoots but they did. Some felt I was taking the credit for their work as well.[10]

With her resignation, Corita was saying goodbye to a relentless schedule filled with teaching, traveling, lecturing, and exhibiting, "I taught for about thirty-two years, and then I really felt that I had finished with that. I was very happy to drop it. The same with speaking. That was the thing I dropped most easily."[11] Corita and her mentor and unofficial manager until 1964, Sister Magdalen Mary (Margaret "Maggie" Martin), were both "demons for work."[12] Sister Mag, as she was known at the IHC, was the "impossible nourishment behind the blooming of the art department."[13] She had scheduled travels for their collaborative slide talks visiting a different U.S. city every second day

← IHC art department, Mickey Myers in purple suit, 1966
↙ *Newsweek*, December 25, 1967
↘ Corita working on serigraphs
→ Prints hanging to dry

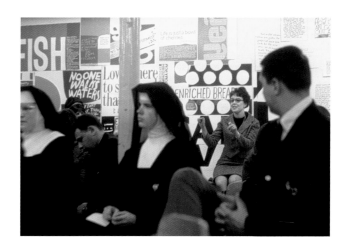

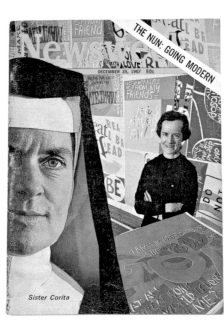

during one month, and that was typical in 1959, even before Corita's marquee appeal had burgeoned.[14]

Corita Kent was leaving behind her over-scheduled insomniac life of teaching, running the art department, lecturing, exhibiting, fulfilling commissions, conducting workshops, and acting as spokesperson for the IHC, as well as icon for the rebellious "modern nun." She was taking leave of being "involved in too many things and constantly trying to remember stacks of deadlines,"[15] within which art making – her primary passion – had from all accounts become confined to a frenzied period in the three-week summer vacation between semesters, taking place in the basement of the college or in the one-room cinder block workshop across from Immaculate Heart College.[16] Despite Corita's seemingly relaxed attitude toward the in-between, speedy character of those work sessions, clearly the arrangement was less than ideal. "This year I did thirty or thirty-five [serigraphs], and printed about a hundred of each. I work very fast, and others help me mix paint and clean up. It's a standing joke that anyone who drops in in August helps."[17] She reflected many years later on the period precipitating her transition:

Other people could see the pace at which I was going, which was really insane toward the end, and I don't think I quite realized it. I was young and healthy, and I said no to so many things that I thought I was saying no to as much as possible. But apparently I wasn't. So when

I found out how simple life was staying with one person and making prints for a whole summer, it began to dawn on me what I had been doing, and I just couldn't do it anymore.[18]

Corita had been living with the Immaculate Heart women her entire adult life: she was with people all the time, and the volume had been steadily increasing. The lure to design her own life, to compose a quieter, more self-directed existence, which would provide ample time for making her art, was powerful.[19]

Call for Renewal
While Corita's ever increasing workload was formidable enough, it coincided with changing circumstances in the Catholic Church in the 1960s: these brought certain institutional problems to the foreground, and brought tensions within Corita's immediate environment – and within her – to a crisis point.

In 1962, Pope John XXIII's Vatican II decree on the "Adaptation and Renewal of Religious Life" called for movement towards modern values. "Post-Vatican II liturgy was to include the use of the vernacular – as opposed to Latin – in holy services such as the celebration of the Mass. The altar was turned to face participants so that they would 'really be at the table,' and the communion wafer was handed to the person receiving it instead of being placed by the priest on the communicant's tongue."[20] For nuns, who had been subject to traditionally gendered roles,

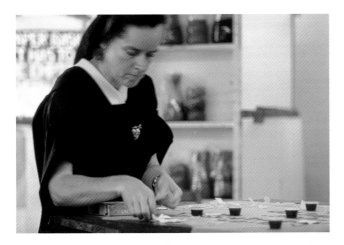

modernization meant a loosening of those functions, fewer restrictions on their daily lives, and a new focusing on social action and service.

The Immaculate Heart Community and College, like many Catholic institutions, were thrown into conflict over how previously accepted traditions were to be revised *in practice*. The role of the sisterhood was service; traditionally sisters were not individuated or permitted to draw attention to themselves, hence the habit, or uniform, and the refutation of birth names.[21] Many nuns were teachers and educational traditions dictated by standardized methods were in place. Corita and the Immaculate Heart of Mary (IHM) nuns largely favored a progressive reading of Vatican II, which included not only modifying personal appearance and seeking more individuation, but taking seriously the Vatican's call for critical examination of their governance and the call to air their objections and propositions – even if these were at odds with the local church hierarchy to which they were supposed to be obedient. Corita and the IHM sisters questioned the notion of apparently absolute obedience that the Los Angeles archdiocese, and Cardinal James Francis McIntyre in particular, demanded – which in itself contrasted with the message of the decree on Adaptation and Renewal of Religious Life. The sisters sought to contemporize their community work, their teaching methods and educational content, and connect more to people's lived experience, particularly through cultural practices. The symbolism invoked by some of those cultural practices,

notably by Sister Corita, was at times regarded by the Cardinal as sacrilegious. Dramatic disputes over the decree's interpretation – amply publicized in the media – ensued between the IHMs and the archdiocese.

From Corita's point of view, "…there was an extreme rigidity on the part of the hierarchy. So that what should have been very normal growing changes were not allowed to be organic because everything that changed created such a big sensation…" People outside the community thought the nuns should continue wearing their habits, and didn't understand how it separated them from the people they worked with.[22] Celia Hubbard recalls that after shedding the habit "Corita chose to wear stylish Marimekko dresses… Corita's fashion sense was very much in keeping with her preference for bold shapes and primary colors in her art, and she loved to dress in a beautiful way."[23]

It was a fateful irony that such a progressive community was located in what seemed to be the country's most conservative archdiocese, with Cardinal McIntyre at the helm.[24] Although the conflict applied pressure primarily on the mother superior and the college president,[25] Cardinal McIntyre's "displeasure was often personalized in Sister Corita,"[26] perhaps because she was so vibrantly in the public eye. Corita had been invited to make a wall mural for the Vatican Pavilion in the 1964 World's Fair that took place in New York, a more prominent venue did not exist.[27] *Newsweek* magazine reported that:

← Corita with *very fine*, edition for Hilton Hotel, New York, 1961
↙ Corita, c. 1968
→ News clipping, *Los Angeles Times*, March 6, 1968

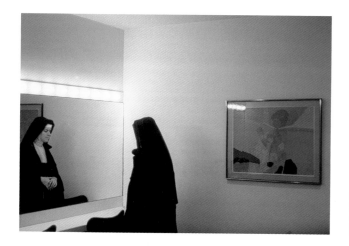

Through her infectious vitality, Corita joyfully subverts the church's neat divisions between secular and sacred. "She merely steps outside the rules and does her dance," says Jesuit poet Daniel Berrigan… "But she is not frivolous, except to those who see life as a problem. She introduces the intuitive, the unpredictable into religion, and thereby threatens the essentially masculine, terribly efficient, chancery-ridden, law-abiding, file-cabinet church."[28]

Corita was frequently targeted for criticism by conservative Catholics,[29] including alumni and patrons whose financial support was considered essential, for her outspoken and engaging style of expressing her views on faith, art, and society. Beleaguered by frequent censure, upon leaving Los Angeles, she was escaping the restrictive judgment of authority that had ordered her life for so long.

Helen Kelley, president of the college between 1963 and 1977, wrote: "That Pope Paul VI had himself called for such review and revision mattered little at the local level. The incumbent archbishop… opposed everything the majority of the sisters proposed, ordered the removal of all Immaculate Heart Sisters teaching in the Los Angeles diocesan schools, and finally presented the community with an ultimatum: either conform with his wishes or seek dispensation from vows."[30]

Cardinal McIntyre did in fact succeed in preventing the reform-minded sisters from teaching in his schools, but was unable to stop their programs and revisions altogether. He asked the Vatican's Congregation of the Religious for ruling on their disobedience. The initial response: "the sisters must curb their experiments and submit to the authority of Cardinal McIntyre." Undeterred, they asked Pope Paul VI to clarify his directive on religious renewal – and, in effect, overturn the congregation's ruling.[31] Ultimately, Rome deemed the IHC's renewal to be too far-reaching. This decision prompted the ensuing split. By 1970, many had left community life entirely, and then came the splintering of the organization. Ninety percent of the remaining IHM members chose to seek dispensation from their vows and reorganize as a voluntary community inspired by religious ideals.[32] The group removed themselves from Catholic Church supervision.[33] Corita's departure had pre-dated the courageous action of the IHM sisters who sought freedom by two years.

A Democratic Form

Frances Elizabeth Kent was born in 1918 to an Irish Catholic family with six children living in Iowa. Five years later they moved to the Hollywood section of Los Angeles. Upon completing her Catholic education, Frances entered the Immaculate Heart of Mary Religious Community and took the name Sister Mary Corita. Religion was important in the Kent family; Corita's sister Ruth and her brother Mark also chose to enter religious orders.

Corita earned her Bachelor's degree from the Immaculate Heart College in 1941 and a Masters in Art History from the University of Southern

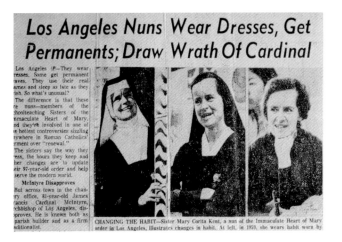

Los Angeles Nuns Wear Dresses, Get Permanents; Draw Wrath Of Cardinal

Los Angeles (P)—They wear dresses. Some get permanent waves. They use their real names and sleep as late as they wish. So what's unusual?

The difference is that these are nuns—members of the schoolteaching Sisters of the Immaculate Heart of Mary. And they're involved in one of the hottest controversies sizzling anywhere in Roman Catholics' ferment over "renewal."

The sisters say the way they dress, the hours they keep and other changes are to update their 97-year-old order and help serve the modern world.

McIntyre Disapproves

But across town in the chancery office, 81-year-old James Francis Cardinal McIntyre, archbishop of Los Angeles, disapproves. He is known both as a parish builder and as a firm traditionalist.

CHANGING THE HABIT—Sister Mary Corita Kent, a nun of the Immaculate Heart of Mary order in Los Angeles, illustrates changes in habit. At left, in 1959, she wears habit worn by

California in 1951. That same year she learned serigraphy from the wife of the artist Alfredo Martinez and began working primarily in silkscreen. At that time, serigraphy was considered a sign painter's medium and was not respected or accepted into some juried exhibitions.[34] A watershed moment that gave the artist a much-needed confidence boost was in 1952 when, unknown to Corita, Sister Mag entered one of her prints, *the lord is with thee*, into a Los Angeles County competition.[35] In the print division, her work won first prize, which was to be the first of many.

For Corita, wide distribution was a populist and Christian principle that determined her choice of artistic medium. "I'm a printmaker…a very democratic form, since it enables me to produce a quantity of original art for those who cannot afford to purchase high-priced art…the distribution of these prints to everyday places of work pleases me, and I hope they will give people a lift…more fun out of life."[36] She rejected what she perceived as an elitist distribution system and deliberately priced her large unnumbered editions of serigraphs inexpensively. Corita's choice of medium was in part influenced by Sister Mag's speculation that they would make more money at Friday night sales held by the department if they offered many inexpensive pieces rather than a few paintings.[37] The various forms Corita would utilize – serigraphs, greeting cards, publications, posters, events, disposable exhibits, murals, and billboards – and the venues through which she was to disseminate her work – churches, community centers, galleries, fairs, corporations, and vans driven to gatherings – made her art available to a broad range of viewers.

In the 1950s Corita's richly colored prints were painterly, typically referring to religious figures or themes from the Bible, such as the madonna, the nativity scene, and various psalms. Corita has cited art historian Dr. Alois Schardt – who taught at the Immaculate Heart College – Ben Shahn, abstract expressionism, and Simon Rodia's Watts Towers as early influences but she discovered her greatest source of inspiration later. "I had already finished school when I met my real teacher, Charles Eames. He was not an art teacher; he was an artist who taught by words, films, exhibits, buildings, classes, visits, phone conversations, and furniture."[38]

Corita introduced words into her pictures in 1955; words infiltrate the pictorial in her prints throughout the late 1950s. *Word picture: gift of tongues*, from 1955, distinguishes text and image in its title, as does *word picture: christ calming the storm*, of 1956, indicating her reliance at that time on figurative subject matter. The former features figures amidst a sea of hot pink and red tones in the bottom section of the print while text fills the relatively neutral color field in the upper two thirds: "When the day of Pentecost came around, while they were all gathered together in a purpose of unity, all at once a sound came from Heaven like that of a strong wind." The serif classical type style predates Corita's individualistic handwriting. The subject matter points to Corita's interest in

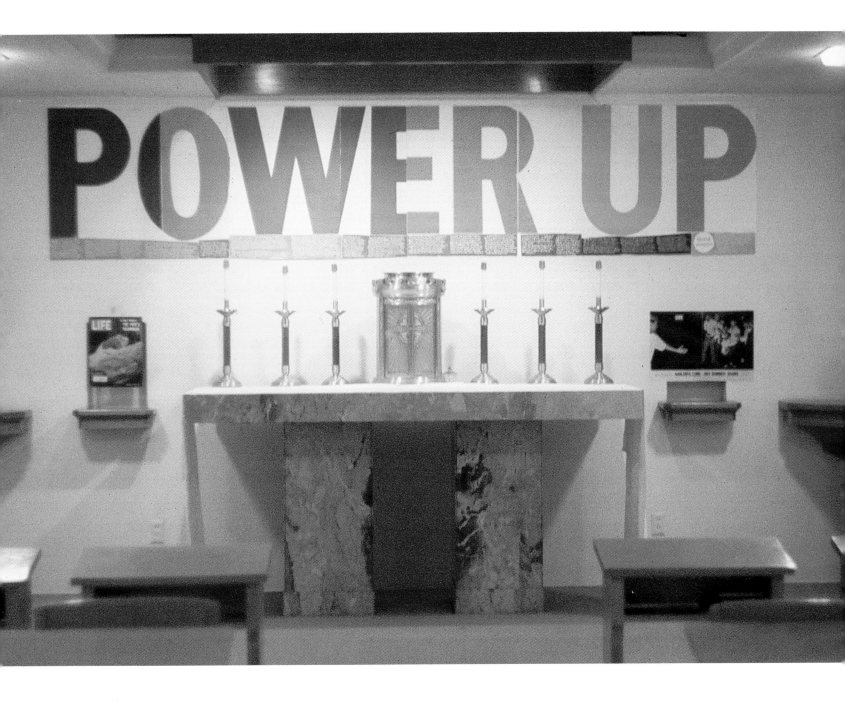

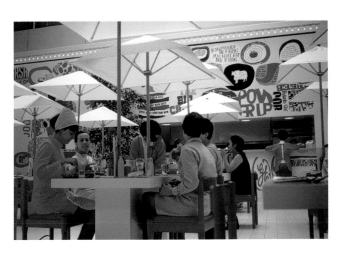

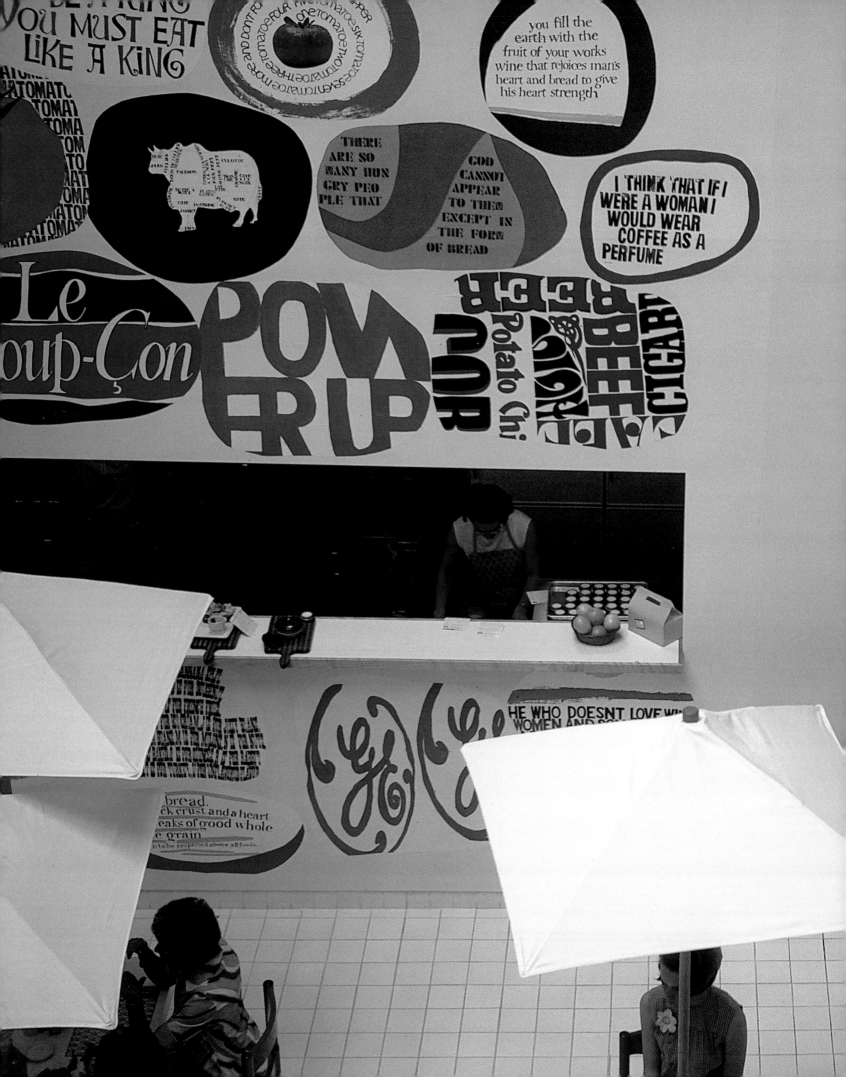

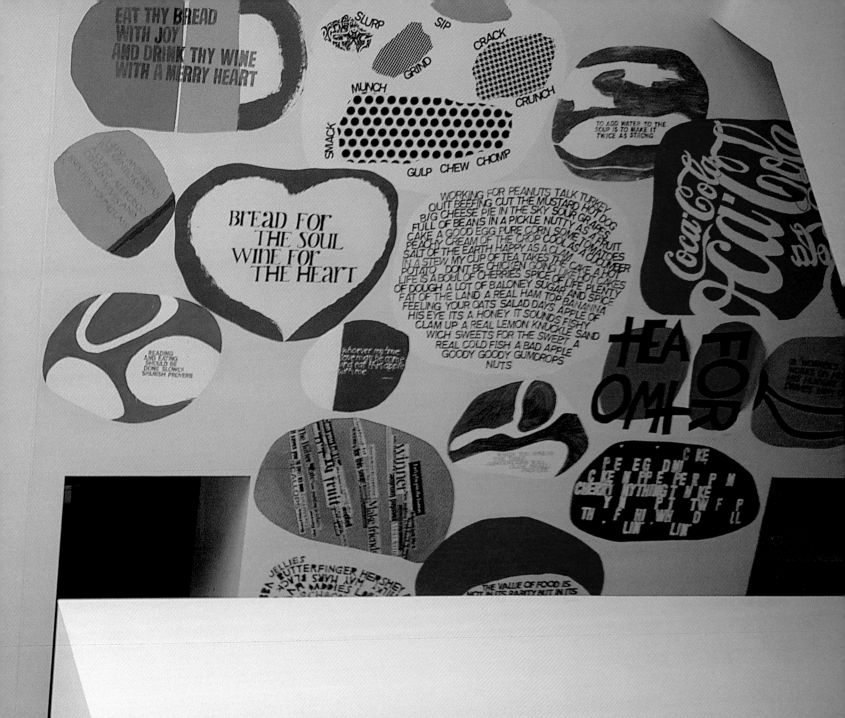

the power of words stemming from religious belief and alludes to their sacredness, the word coming down from on high.

The artist also took notice of "posters…I got ideas of there being different possibilities of using letter forms. And I always think of the letter forms as much as objects as people or flowers or other subject matter."[39] By 1960, Corita's figurative style is replaced by a growing use of abstract color fields and shapes, many with psalms written out to form the central focus. By 1961, words primarily compose her prints. Over the following years, Corita increased their usage and scale until word became image.[40]

The escalating size and quantity of words in Corita's prints in the early 1960s can be linked to her growing interest in her immediate urban environment and its signage systems, which was also developing speedily and exerting visual force. The U.S. post-WWII financial boom produced new degrees and levels of consumer culture that registered in everyday life through media multiplication, including advertising on billboards. Hollywood must have felt like the pinnacle of that proliferation, a veritable explosion of images, slogans, textures, and colors.

Corita's prints in the mid-1950s display rich though muted colors, distinct from the clear intense colors she began using a few years later. Sister Mary William (Helen Kelley) explained, "Our colors are the colors of the marketplace, the colors of life-giving foods, and our sounds are the sounds of the here and now."[41]

Although one does not usually associate the religious principles of the Catholic Church with supermarkets and the signage environment of city streets, for Corita, such vernacular culture was a source of inspiration and raw material. Corita's fascination with advertisements and the languages of commercial culture extended to a fascination with the vernacular landscape which the city of Los Angeles offered. Whereas billboards and "decorated sheds" were indications for architectural critic Peter Blake that the contemporary city of the 1960s resembled "God's Own Junkyard,"[42] Corita welcomed the "clang and clatter" of what she called "marvelously unfinished Los Angeles."[43] She elevated the commonplace through her methods of "snitching" symbols to expand their meaning. Harvey Cox has written that,

Corita won my heart because she had an urban sensibility. She loved the city. The world of signs and sales slogans and plastic containers was not, for her, an empty wasteland. It was the dough out of which she baked the bread of life. Like a priest, a shaman, a magician, she could pass her hands over the commonest of the everyday, the superficial, the oh-so-ordinary, and make it a vehicle of the luminous, the only, and the hope-filled.[44]

At the end of 1962, Corita began adopting package design motifs and quoting advertising slogans. A pivotal work of that year, *wonderbread*, consists only of red, yellow and blue polka dots, inspired by the bread company's packaging. "As

← *left*, 1967
↙ *to all of my calling your name*, 1962
↗ Mobil gas station signage, Los Angeles
↘ Street signage, Los Angeles

the dots from the wrapper moved over into the picture…some people began a conversation and discovered them to be in the shape of hosts, though this was not in the mind of the bread maker or the picture maker."[45] Corita appropriated the colors of the marketplace and the aesthetics of promotional culture to situate her messages in contemporary popular language. She crossed over to advertising communication to adopt poetic slogans and imbue them with spiritual and social meanings. In *for eleanor*, 1964, "The big G (of General Mills) stands for Goodness." In *someday is now*, 1964, "the part of the print filled with fragmentary block letters spells SAFEWAY super-market; SAFEWAY makes its presence felt regard-less of whether the words can be read."[46] The title of the four-part print, *power up*, 1965, derives from a gasoline ad. *Handle with care*, 1967, urges: "see the man who can save you the most" – the man is your Chevrolet car dealer and what he can save you is money. In *somebody had to break the rules*, 1967, the title, appearing in jumbled-up form in the print, is taken from a Dash laundry detergent campaign. "Come alive, you're in the Pepsi generation!" becomes simply "come alive" in several prints from 1967. Humble Oil is the company "who cares" and claims, "the handling is in your hands." And of course, *things go better with* Coke.[47] According to the *New York Times*, Sister Corita…did for bread and wine what Andy Warhol did for tomato soup.[48]

By 1964 her iconography was derived predom-inantly from the booming media environment and urban surroundings.

↓ Wonderbread
billboard, Los Angeles,
1961
↘ *for eleanor*, 1964
↘↘ *wonderbread*, 1962
→ *someday is now*, 1964

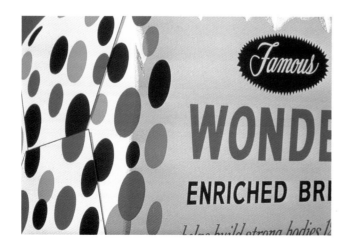

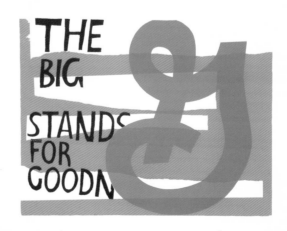

The sign language is almost infinitely rich....Up and down the highways (good symbols too) we see words like "Cold, clear, well-water," "The best to you each morning," "Have a happy day," "Sunkist," "Del Monte's catsup makes meatballs sing," that read almost like contemporary translations of the psalms for us to be singing on our way. The game is endless, which makes it a good symbol of eternity which will be a great endless game.[49]

The free flow between discourses – scripture and advertising – in Corita's imagination and experience, was evident in her philosophy and in her artistic output.

Maybe you can't understand the psalms without understanding the newspaper and the other way around. Maybe that's why it sounds so good when a line from the newspaper is inserted after each line of a psalm – any lines – and read aloud. Maybe they were never meant to be separated....We choose to LOOK *at* LIFE *all the* TIME, *and though we realize that they are in one sense adult comic books, they are also full of things that speak. A photo of a hurt soldier becomes a holy card...*[50]

In 1964, English professor and writer, Samuel Eisenstein was moved by his visit to the IHC Mary's Day celebration that Corita had orchestrated. He sent her a letter about his experience; including in it something he had written on Mary, which inspired her to make the print, *the juiciest tomato of all*, 1964. The print is an emble-

matic expression of that free flow between the religious and the commonplace, between systems of symbols, which Corita embraced. Using Eisenstein's words, it begins:

The time is always out of joint...If we are provided with a sign that declares "Del Monte tomatoes are juiciest" it is not desecration to add: "Mary Mother is the juiciest tomato of them all." Perhaps this is what is meant when the slang term puts it, "She's a peach," or "What a tomato!" A cigarette commercial states: "So round, so firm, so fully packed" and we are strangely stirred, even ashamed as we are to be so taken in. We are not taken in. We yearn for the fully packed, the circle that is so juicy and perfect that not an ounce more can be added....

The piece caused a stir as it was regarded by some as an irreverent desecration of a sacred symbol: Cardinal McIntyre prohibited it from being displayed. In protest, the *National Catholic Reporter* ran a version of it as their Christmas insert. Corita seemed unfazed by the "offense" and explained, "A word like tomato, which has been distorted in some circles, is interesting to restore to a place of beauty – a lovely fruit to look at." With quick wit, she added, "After all, Mary, Mother of Christ, has had her name on buildings, bridges, and so forth."[51] Recently reading his text, which appeared on the print, Eisenstein reflected,

...I really wonder whether it could ever have been written without the inspiring breath of Corita

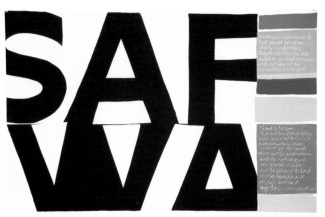

above and behind. She so piquantly exemplified daring to leave the rigid confined circle of orthodoxy and step into an area not defined and clearly dangerous. She stood to lose a great deal – in fact her entire committed life. She made her moves with such insouciance, with such a smiling air of: "look, it's nothing much, try it," that she gave numerous students and friends their freedom.[52]

Corita's compositions made between 1964 and 1966 are primarily silkscreened on a material called pellon, which was commonly used for lining clothes. These 1964 and 1965 works use the white of the cloth-like paper as a background for brightly colored phrases and letterforms that broadcast appropriated messages in a centralized compositional fashion – some neatly fitting into the perimeter of the print, and others featuring enlarged textual fragments that give the impression of bursting beyond the paper's edge. In her 1966 works, slogans and sayings seem to float and interlock, which in conjunction with distorting and spatializing techniques, create a sense of motion. A single print, for instance *we care*, or *let's talk*, appears to capture an active arrangement of slogans and references, as if glimpsing an abundantly mediated environment, perhaps while walking or driving.

Between 1965 and 1969, Corita's work composed pictorial space as a forum in which a carefully orchestrated dialogue between texts is typographically expressed. The work quotes, combines, extracts, highlights and layers elements from a wide array of cultural sources including advertising slogans, street and grocery store signage, poetry, scripture, newspapers and magazines, theological criticism, and song lyrics. Writings by Langston Hughes, Walt Whitman, Martin Luther King, Jr., Jefferson Airplane, Albert Camus, Rainer Maria Rilke, the Beatles, Maurice Ouellet, Gerald Huckaby, Robert Frost, Alan Watts, and Leonard Cohen are quoted; Daniel Berrigan, Gertrude Stein, and E.E. Cummings being favorites.

Although authority is conferred on certain kinds of speech that are readily preserved in public records and historical archives, vernacular speech such as ad phraseology arrives and disappears from circulation swiftly. In Corita's art, the fugitive elements of ephemeral culture are given permanence. In 1977, when questioned about how the legibility of phrases such as "a tiger in your tank" would fare over time, the artist responded: "I don't think I ever worry about something I do lasting forever. I think at that time, those were very meaningful to some people, and it was a kind of contagious, fun thing that I got into." She believed her prints would stand up visually. Corita did not subscribe to the notion that art is timeless, or that things that last longer are better than things that come from, and contribute to, a period.[53]

In the culture of protest, which typified the late 1960s, posters and graphic materials were important tools that carried information and galvanized people. Declaring in 1967: "I admire people who march. I admire people who go to jail. I don't have

← *let's talk*, 1966
↙ *the juiciest tomato of all*, 1964
↘ *we care*, 1966
→ *stop the bombing*, 1967

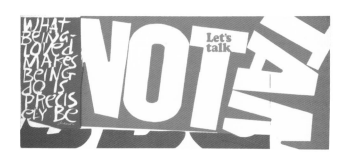

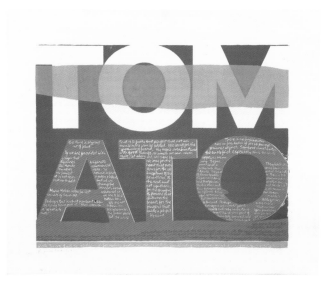

the guts to do that. So I do what I can," Corita turned her attention to racism and poverty, U.S. military brutalities in Vietnam – brought to the foreground of her awareness by Daniel Berrigan – and the conflicts between radical and conservative positions in the Catholic Church. *Stop the bombing*, of 1967, is a red, white, and blue print with words by Gerald Huckaby, that begins: "I am in Vietnam – who will console me? I am terrified of bombs, of cold wet leaves and bamboo splinters in my feet, of a bullet cracking through the trees, across the world, killing me…." "Stop the bombing" is superimposed over the color ground of the print, its letterforms unfurling as if dropped from the sky. *Let the sun shine*, a nearly fluorescent yellow print from 1968, consists of an image of Pope Paul VI – degenerated nearly to the border of abstraction, and the words "let the sun shine in" followed by a quote by Rabbi Arthur Waskow. Corita regarded exercising her voice for social commentary as a right and requirement:

If we separate ourselves from the great arts of our time, we cannot be leaven enriching our society from within. We may well be peripheral to our society – unaware of its pains and joys, unable to communicate with it, to benefit from it or to help it. We will be refusing to care about the fight to free man that James Baldwin speaks of: "The war of an artist with his society is a lover's war. And he does at his best, what lovers do, which is to reveal the beloved to himself, and with that revelation, make freedom real."[54]

Art as Social Process

Corita Kent's art practice originated, formed, and developed within the milieu of the Immaculate Heart situated in Los Angeles. Upon leaving that environment, a dramatic shift occurred in her work. Formal differences and content variances between serigraphs made in 1969 and those made in 1970, are sudden, even shocking. Deprived of her influential contexts of many years, much of the complex spirit, formal innovation, and critical force of her prior work vanished.

In 1969, Corita made a series of small-scale prints titled "Heroes and Sheroes"[55] that layer documentary material, including images from *Life*, *Newsweek* and *Time*, which she considered "contemporary manuals of contemplation,"[56] with textual fragments, resulting in compelling statements about the then-current political landscape. The times were marked by cultural and political activism in the form of the anti-Vietnam war movement, the civil rights movement and struggles for racial equality, feminism, and a generalized conflict between those who sought to challenge, revise, and overturn existing authority structures in society and those who sought to hang on to and further reproduce the status quo. Corita's "Heroes and Sheroes" includes *phil and dan*, which consists of a news photo of Philip and Daniel Berrigan burning draft records with napalm in protest of their country's crimes in Vietnam at a Selective Service office in Catonsville, Maryland on May 17, 1968. The two were part of what became known as the Catonsville Nine, a group

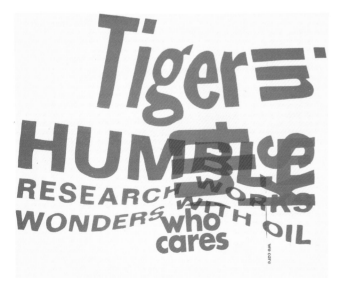

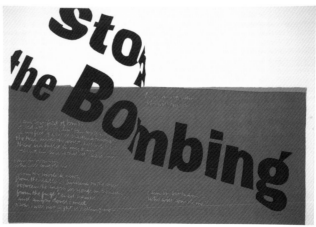

of clergy and laypeople peace activists. They were arrested and Father Philip Berrigan became the first Catholic priest in the history of the United States to serve sentence as a political prisoner.[57] Father Daniel Berrigan was sentenced to three years in prison, but refused to serve the time and went into hiding. The FBI apprehended him after several months and he served sentence until 1972. Another print, *if i*, highlights a picture of Coretta Scott King at her husband, Martin Luther King, Jr.'s funeral, alongside a quotation from her and a text about the "creative power of the female, of the negative, of empty space, and of death," by theologian and writer Alan Watts. "Heroes and Sheroes" juxtapose fluorescent colors to elicit dynamic effects, as did some of Corita's prints of 1967 and 1968, and have a visual affinity with both political graphics and psychedelic concert posters from the time.

Then, beginning in 1970, Corita's art grew increasingly reliant on color splashes and platitudes. Compositions are often made using a single quotation or maxim, handwritten, rather than transforming word into image through typographic experimentation; color splotches and shapes typically form the background. *Rest* consists of a few strokes of color surrounding the words, "today is the first day of the rest of your life." *Very* is composed of multi-colored circles, oddly reminiscent of the round shapes in *wonderbread*, 1962, and reads: "I love you very." In 1971 she began making watercolors, with similarly sentimental results. After 1969, Corita rarely used

↓ *E eye love*, 1968
↘ *let the sun shine*, 1968
↘↘ *phil and dan*, 1969
→ *rest*, 1971

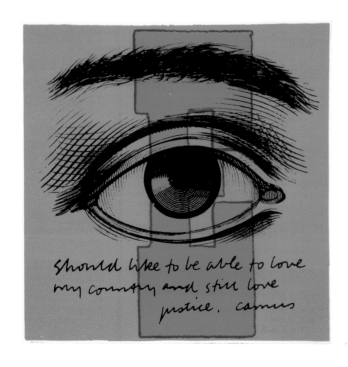

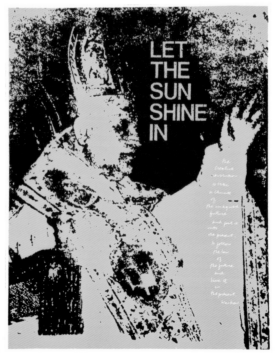

critical juxtaposition, layering, and montage as methods. Except for her distinctive handwriting, and allegiance to quotations and intense colors, one could misread her 1960s work and post-1970 work as being done by two different artists. Speaking about this aesthetic shift, Corita observed, "The serigraphs were bold, are bold, and they make statement. The watercolors, on the other hand, make conversation…I feel that the time for physically tearing things down is over. It is over because as we stand and listen we can hear it crumbling from within."[58] Corita was not alone in her "activism exhaustion." Many cultural protagonists of the sixties suffered similarly, and at the close of the decade, withdrew from public participation into privacy.

Although the divergence between the 1960s work and that which followed is extreme, compositionally and conceptually there is a strong resonance between the latter and the prints Corita was making between 1959 and 1963, though with fewer biblical references. Her palette is simplified and consists of clearer colors, but the marriage of inspirational phrase and color shape or field is congruent. In the scheme of Corita's oeuvre, it is the bodies of work made between 1962 and 1969 that remarkably contrast with what came before and after.

The dissimilarity between Corita's 1960s work and that which followed, suggests that the former was due not only to the larger perspective of 1960s cultural and political movements, but to the vibrant context of her creative community within which nuns, teachers, students, visitors, and even the media participated, and contributed to. Although Corita was singled out as the guiding force and spokesperson for the college's art department, and the signature on the prints was hers alone, deeper inquiry shows that the department's achievements as well as her artworks were the results of social processes. When reading the *Irregular Bulletin*, written and edited by Sister Magdalen ("Mag") Mary and inventively designed and produced by "industrious students and dedicated professors" of the art department, and in reviewing the public record about Immaculate Heart activities and Corita's work specifically, intricate layers of collaboration are revealed. Large-scale disposable exhibitions and the Mary's Day events that Corita initiated (discussed from p. 35) are indicative of the collaborative framework and spirit at the IHC.[59]

The reputation of the art department, though often associated primarily with Corita, was largely due to the efforts of Sister Magdalen Mary, who from 1936–1964 headed the department, taught in it, and organized its programs. It was under her influence that the secular and the sacred were redefined according to her engagement with vernacular culture as creative terrain. Sister Mag, a strong-willed, ambitious, and vigorous force by all accounts, figures into Corita's story prominently as the key person who encouraged her to overcome anxiety and self-doubt and become a teacher. A radical and innovative educator herself, Sister Mag influenced Corita profoundly.[60] She

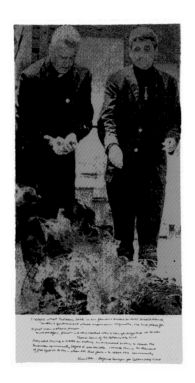

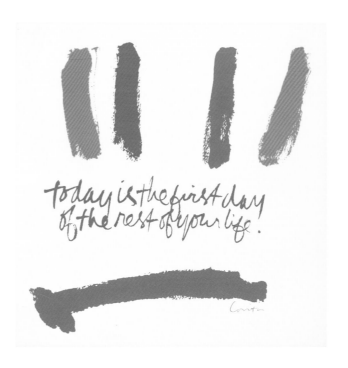

tirelessly supported and promoted Corita and her work, and frequently advised her about all kinds of issues, including aesthetic ones. She was known to tell Corita what she should add, omit, or change in a given composition – and Corita was known to follow her lead. The two traveled together throughout the U.S., Europe and the Near East, in the 1950s and early 1960s, with Corita obsessively snapping photographs. This began an ongoing interest in photography, which would become integral to her artistic practice. During their travels Sister Mag and Corita built up the vernacular and folk art collection for the college that Sister Mag had started, the Gloria Folk Art Collection, because they believed: "…the students should be surrounded by real art….But we really had practically no budget at that time. So we started collecting very simple things, like Japanese paper things, objects that were beautifully made and were part of somebody's tradition."[61] According to some, the sisters' relationship gradually became afflicted: Sister Mag felt Corita did not give her due respect once she became renowned, and Corita reportedly felt over managed and increasingly pressured to make good for the college, in part by producing saleable work and going on the road relentlessly.[62] Partially due to those differences, in 1964, Sister Mag went to England to focus on collecting and studying and Corita was promoted to head of the art department.

Corita engendered devotion from many a student inspired by her presence and manner of teaching. Many aimed to please her in whatever ways they could, including contributing physical and intellectual labor to her art. But this didn't prevent resentments from developing in some around the fact that their tangible and intangible contributions to Corita's work, her celebrity, and to the college went unacknowledged, and by some accounts, unappreciated.[63]

Corita demanded a lot from herself and from her students. Rule Two of the art department rules states: "General duties of a student: pull everything out of your teacher. Pull everything out of your fellow students." Rule Three: "General duties of a teacher: Pull everything out of your students."[64] Answering the question to what degree her students influenced her work, she replied:

I think there was a great exchange between us. First of all, we saw the same things, because we usually went to exhibits together. And then I think there was a great interchange as far as the classwork was concerned, as to assignments I would give them and ways they would interpret those assignments. I think we probably, from working so close together, had a very similar way of looking at things and probably similar tastes… I think it was really a mutual kind of influence…[65]

Corita's charisma and notoriety drew students to her, but it also got in the way: "It was a very difficult time for the students because I was away a lot more than they thought I should be away…. I thought that was good for them because I would

← Photo of Sister Magdalen Mary and Corita, published in the *Irregular Bulletin*, 1959
↙ *Survival With Style* in the making at IHC, 1966
↗ Serigraphy workshop at IHC (Corita, fourth from left)

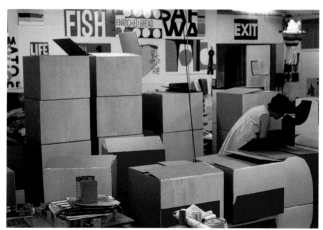

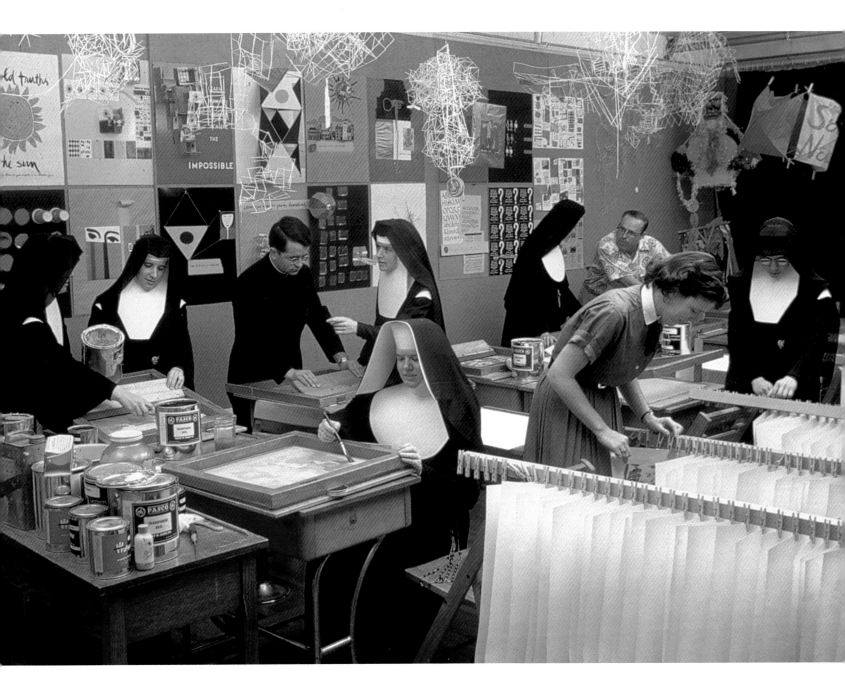

leave them with a lot of work to do.... So the fame sort of got in the way.... And they were just angry. But as I say, students were angry in those days."[66]

Beyond general cross-influences that can happen in any close-knit setting, Corita relied on and received help from students, colleagues, and friends who assisted in printing her serigraphs. Furthermore, "...in those days, I was surrounded by very literate people. That community had some of the best women you could ever meet, and there were people in all different fields. So sometimes people would point things out to me or send things to me."[67] One can readily speculate that engaging in Corita's participatory environment involved not only contributing labor and technical assistance, and supplying references, but was bound to include aiding design, aesthetic, and content discussions and decisions. Many hands and minds may well have contributed to any given artwork, series of prints, or turn of method.

The fundamental creative and educative principles as well as the spirit identified with Corita's person and art were communally derived and shared. Corita did not hide that, but press coverage typically focused on her, and tended to omit the texture of the community's many generative individuals and collaborative methods. It would be difficult to ascertain definitively who, specifically, originated particular ideas. Corita was undeniably a catalyst and a force, however, it is vital to register the fact that informal processes of collaboration were at the heart of the IHC, its art department, and Corita's printmaking while there.[68]

Somebody had to break the rules[69]

Although Corita was committed to making her work accessible, she did not define accessibility based on an imagined lowest common level of visual literacy – quite the opposite. Her prints from the 1960s embodied broad knowledge, visual complexity, and sophistication, and thereby expressed deep respect for viewers. Corita's work of that decade proposes a symbolic template for blurring the boundaries between art and design, aesthetics and politics, and for decentralizing authority – be it monolithic or monologic – within the larger context of then-current struggles over restructuring society.

Many rules of legibility central to the formalism of modernist design principles are broken in Corita's 1960s work. Language is excerpted, dis-assembled, reassembled, recontextualized. Typography is distorted, turned upside down, and reversed. Letterforms are ungrounded, float, and interlock. The graphic space in some prints is layered with handwritten quotes integrated into individual letters.[70] Handwriting done "in the spirit of" Corita's became a typographic blueprint for laying out bible verses in church posters; her style was often quoted in banners and printed material, thereafter identified as "nun art."

Corita's visual processes were in part informed by a distinction between contents and aesthetics. (Rule Eight "Don't try to create and analyze at the same time. They're different processes.") She encouraged students to "look at everything" in order to find a visual, or material, starting point,

← Sign at Chevrolet dealership, Los Angeles, 1967
↙ *greetings*, 1967
↘ Magazine copy, cut-up, bent, and recombined by Corita, 1967
→ Grocery store poster, cut-up and recombined by Corita, 1967

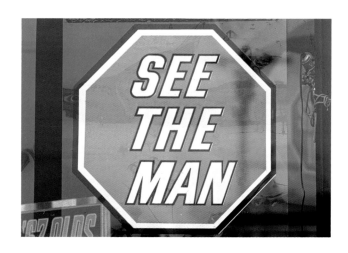

and then work with it – play with it – "eventually you'll get somewhere, and stumble upon content in the process." Although Corita's serigraphs seem to exemplify a more integrated approach to form and content, some of the conceptual tools she used to generate them illustrate how decontextualizing, recasting, and juxtaposition function as productive forces in her art making.

A simple device Corita called a "finder," a "looking tool" that "helps take things out of context, allows us to see for the sake of seeing, and enhances our quick-looking and decision-making skills,"[71] was key to her process of decontextualization.[72] A finder could be an empty slide frame, a cut-up piece of cardboard, or a camera. As a viewing and cropping apparatus, a finder excludes everything around it, and, in Corita's words, allows for "[viewing] life without being distracted by content. You can make visual decisions – in fact, they are made for you."[73]

Corita often took her students to busy intersections and instructed them to look through finders, close up as well as from a distance, declaring that at a single intersection there was enough raw material for at least sixteen hours of scrutiny. Speaking about such excursions, Corita said:

I remember at that time I was very excited about billboards. I guess it was the whole era of pop art. And I also got very excited about sections of the city that I would have called ugly before. I took the students to…two Mark C. Bloome tire companies… we just went there, either with cameras or with little finders….And we just spent the afternoon, two afternoons, one at one place and one at the other, just looking. And of course, taking off small pieces, little rectangles, that are like taking a picture, you can take a section, or maybe a section of a letter [where] not the whole word shows and certainly not the whole gas station.[74]

Corita was an avid photographer who shot thousands of slides documenting her travels, students' work, teaching references, exhibits, Mary's Day processions and other IHC events. She was inspired by the Eameses' photographic documentation of the everyday. Her slide archive includes the following categories: cookies, toys, presents, flowers, seeds, puppets, trade fairs, mountains, textiles, artists' work, theater, coke bottles, cards, icons, and boxes, and as a whole, formed a visual cache for presentations, teaching, as well as for illustrating the *Irregular Bulletin*. Corita also photographed magazine ads, billboards, hand-painted signage, street signs, and other references, which were primarily raw material for her printmaking process. She isolated fragments, and – in the process of framing an image through the camera's viewfinder – highlighted a particular shape, part of a slogan, or portion of an image.[75]

Photography was the tool that allowed Corita to mediate between the multi-dimensional experience of looking at the visual world and the two-dimensional possibilities of a serigraph. For example, she noticed that, through a viewfinder from a particular angle, type on a flat page or

billboard appears three-dimensional and suggests a quasi-architectural space. She captured dynamically distorted type and translated it into the two-dimensional surface of the photograph. Pushing this distortion process further, she crumpled, cropped, tore, and reformed advertisements and then rephotographed them. She then isolated the distorted type and transferred it to stencils used to produce individual layers in an overall composition. Pieces made using this method include *ha* and *now you can*, both 1966, and *fresh bread* and *that man loves*, from 1967.

Psychedelic concert posters of that era typically feature distorting type treatments, which look as though words have been poured into a shape, for instance a butterfly or a thought balloon. In those posters, type gets rounded, misshapen, and reshaped to suggest fluidity. Corita's typographic distortions differ in that they are not fashioned to fit inside another form. Instead, type itself dictates shape and composes central imagery, pictorial space, foreground and background. Using Corita's technique described above, manipulated and layered type is made to suggest a graphic three-dimensional space with an architectural sensibility, distinct from existing typographic possibilities of the 1960s. The results of Corita's low-tech type manipulations have since become defining features of many computer applications. Corita recalled her impetus for distorting letterforms:

I was taking photographs…for one of these Mary's days, we decided to cover every door of the

administration building with one big poster that was the size of a door. So every student made about five. I was taking photographs of them one time and taking sections of some because they were very beautiful. One of them was curved, as I was taking the slide, and I thought, "Oh, that would be a nifty idea." So that year, I think almost in all of my prints, I took pictures from magazines and combined them the way I wanted and then I would curl the paper to go the way I wanted it to and shoot the photograph, the slide, and then enlarge that and cut the stencil from that.[76]

Another important design strategy for Corita is her use of cut-and-paste techniques, predating punk graphics by well over fifteen years. This strategy developed in her lettering and layout classes that involved collaboratively making placards and printed matter composited from various lettering styles and methods of individuals. Corita was clearly inspired by the layout of the Immaculate Heart College's art department newsletter, the *Irregular Bulletin*, published intermittently from 1956–1963,[77] which relied heavily on collage of cutout type and recycled material. The Bulletin editor, Sister Mag, was also the mastermind of its layout, in which headlines are pasted together from newspaper clippings in ransom-note style; typewritten essays are cut up into individual words, phrases and paragraphs, and scattered across pages – interconnecting and overlapping with images. Some flyers for Corita's "one-nun exhibitions" use similar techniques,

← Class project, IHC art department, 1964
→ From top to bottom and left to right, *jesus never fails*, 1967, *that man loves*, 1967, *handle with care*, 1967, *with love to the everyday miracle*, 1967, *ha*, 1966, *now you can*, 1966

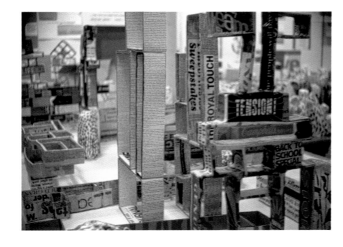

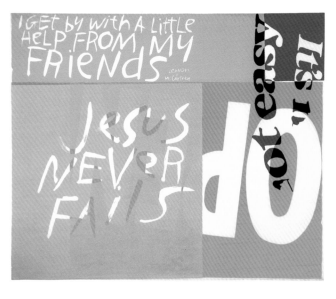

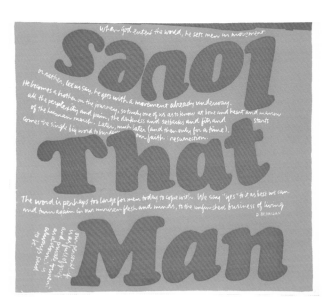

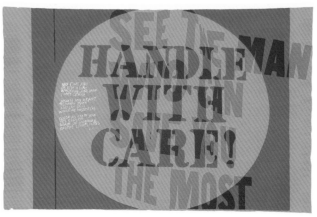

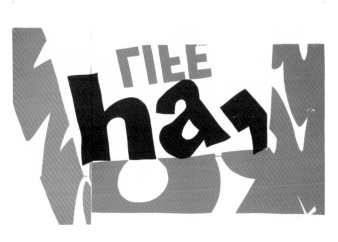

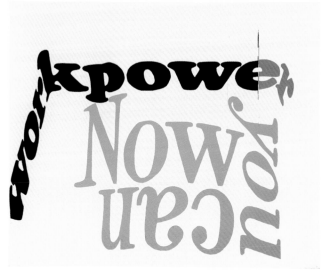

predicting Jamie Reid's design for the Sex Pistols' album cover *Never Mind the Bollocks*, in 1977.

Collage played an important conceptual role in Corita's image making. The viewfinder is essential to her investment in formal decontextualization, and critical juxtaposition, as a method, is important in her recasting processes, and to the new content that results. Although her imaginative use of collage factors into many of her silkscreen prints, it is not immediately legible, due to their seamless quality. Consider for instance, *handle with care*, 1967, which layers an image derived from a photo of a button that reads, "handle with care" screened in equivalent tones of green letters on orange, and an advertisement for a Chevrolet car dealership photographed from crumpled newspaper that reads, "see the man who can save you the most." The latter "phrase as image," printed in transparent bright red ink, is superimposed onto the above-mentioned. A complex optical effect is created by the overlay, producing different alternating colors, depending on whether green or orange lies underneath. The overall effect of this specially colored collage is that the two slogans combine and intertwine in a seemingly reconciled manner.

How juxtapositions produce new contexts and generate content is also vividly demonstrated in Corita's 1967 book, *Footnotes and Headlines*.[78] The fifty-two page "play-pray book" is a tableau of typographic experimentation combining brightly colored type collages with Corita's writing – "prayers that read like a grocery list." The collages

↘ *Footnotes and Headlines: a play-pray book*, 1967
↘↘ Spread from *Footnotes and Headlines*
→ Spread from *Footnotes and Headlines*

turn fragments of letterforms into backgrounds, on top of which advertising slogans in various configurations, sizes and typefaces are laid out. The volume explores and challenges the conventions of reading. Marshall McLuhan, in a cover blurb, called it "a new form of book…an X-ray of human thought and social situations." Each page in *Footnotes and Headlines* is apportioned with a section for Corita's written text, which lies on top in the initial page spreads, and the montaged slogans and text fragments are in the bottom section. After a few page spreads, the order is reversed – found fragments or "text as image" fills the top part of the page, and her writing rests in the bottom. The book as a whole, and every page in itself, plays with Corita's concept of "how a footnote almost became a headline."

By pushing the boundaries of cutting and pasting as a graphic strategy, Corita turned decontextualization and recontextualization into emblems for her production of meaning, and, in the process, resolved the distinctions she professed allegiance to, between form and content and between creative and analytic thinking.

Temporary Art

Though certainly they are the most lasting and coherent of the mediums she employed, Corita's serigraphs and works on paper are only part of her artistic output. In addition to prints and other publication formats, Corita focused her creative intelligence, design principles, and organizational skills on producing large temporary exhibitions – such as the collapsible cardboard-box exhibit, *Survival With Style*, 1966, and on choreographing extensive events – such as the annual Mary's Day celebrations held at the college, all of which stemmed from her art classes and collaborations with her students.

In the case of Mary's Day, starting in 1964, Immaculate Heart College president Helen Kelley invited Corita to take over its planning.[79] The art department therefore became primarily responsible for making the event, although Corita attempted to involve the other departments, given that Mary's Day celebrations were labor intensive and involved hundreds of participants and visitors.

Mary's Day was a tradition at Immaculate Heart. The school was dedicated to her. The day had originated in another time, and the circumstances of that time had formed it. There was a solemn procession with students dressed in black academic caps and gowns – only the faculty looked festive in colors from many universities. There was a quiet Mass and sacred music….There were speeches and awards and a sit-down meal….I was commissioned to make the day new.

As with any commission in those days, I started it going and the students did immense amounts of work and shared much of the responsibility…. I think celebrations are always meant to instruct and inspire, to empower people to use their own creative skills through images and ritual to action….Our celebration grew out of a desire to

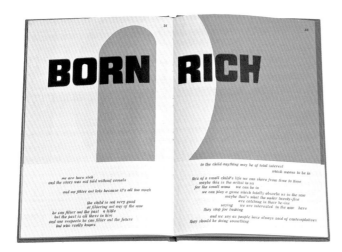

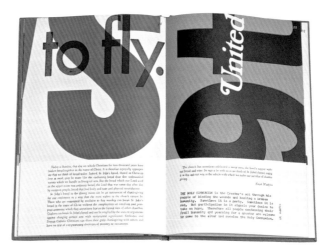

make Mary more relevant to our time – to dust off the habitual and update the content and form.[80]

The 1964 Mary's Day expressed Corita and company's foray into supermarket and billboard culture and celebrated the everyday through food: "We lift the common stuff – groceries and signs about groceries – out of the everyday and give it a place in our celebration."[81] The food theme was invoked to celebrate abundance, but also to make people aware that much of the world's population did not have enough to eat. Vatican II had impelled the IHM sisters to attune themselves to examining the problems that affected the constituencies they sought to aid and countering injustices in current society. So issues such as hunger and poverty, as well as finding joy, color, and inspiration in supermarkets and in the relatively new language of advertising, were articulated in the name of Mary, bringing her "down to earth." In Corita's serigraph, *mary does laugh*, of 1964, the central text fragment reads: "mary does laugh, and if she were alive today, she would shop at the market basket." The Market Basket supermarket chain had a gigantic store across the street from the IHC, where Corita collected discarded signage to be used as class material, classroom decorations, and specifically for the '64 Mary's Day. Cropped billboards with Kodacolor pictures of Del Monte juicy-looking canned fruit, whole raw chickens, and supermarket weekly-sale signs adorned the fence on the driveway to the college. Hundreds of signs were made using fragments of supermarket posters

featuring pictures of hamburgers with Hunt's catsup, Campbell's soups, and giant cans of coffee, which became placards carried by nuns, students, and visitors in the procession. Other placards read: "Come to the feast," "Free Eggs," "I like God," "God Likes Me." Colorful pictorial advertising sections hung in the windows of the school. Jan Steward describes how the theme extended to the interior design atmosphere:

Five hundred loaves of bread and five hundred baskets of fruit were stacked on tables before the altar. People processed to the stage, bringing more food. Newspaper galleys, with their messages of disaster, hung down the walls, grim reminder that our work, to make changes, was heavy….our tables were cardboard cartons that had been painted and collaged with the words of the day – the words of Kennedy, King, Gandhi, Pope John XXIII, and others. These same boxes had also been used in parts of the ceremony as walls or structures to walk through.[82]

As with most Corita steered projects, reading, researching and gathering quotations was an important aspect of the work. In preparation for Mary's Day, "the students would collect gobs of quotations."[83] All art majors at the college were required to be English minors.[84]

Preparations begin in February or March with student-faculty brainstorming sessions to determine a theme and ideas for the verbal-visual expression

← Announcement for Mary's Day, 1964
↙ Box placards, Mary's Day, 1964
↗ Placards, Mary's Day, 1964
↘ Pepsi slogan, Mary's Day, 1964
Next page: Mary's Day, 1964

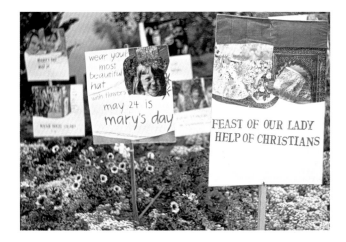

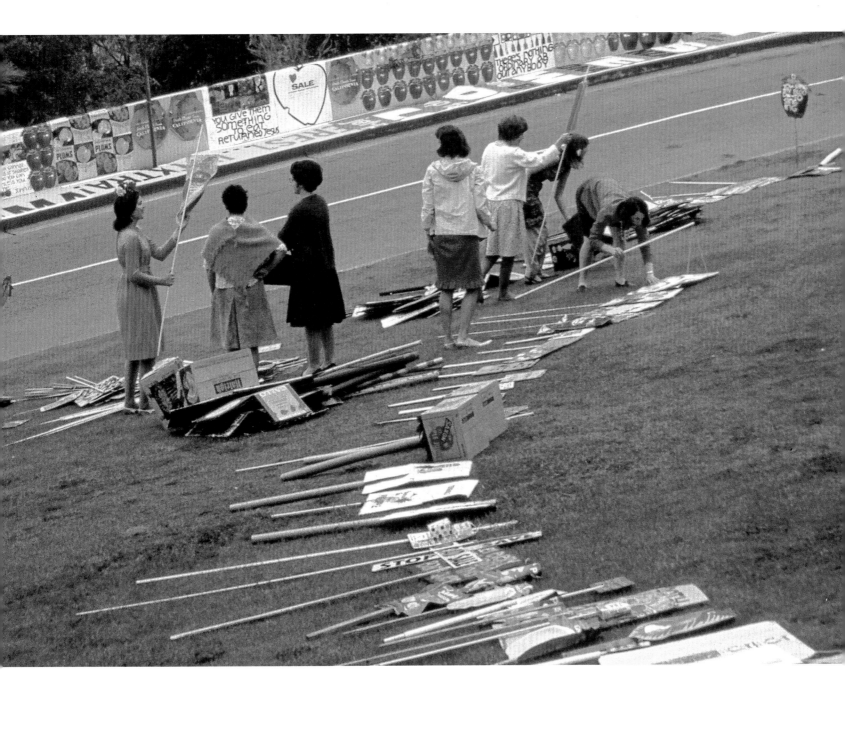

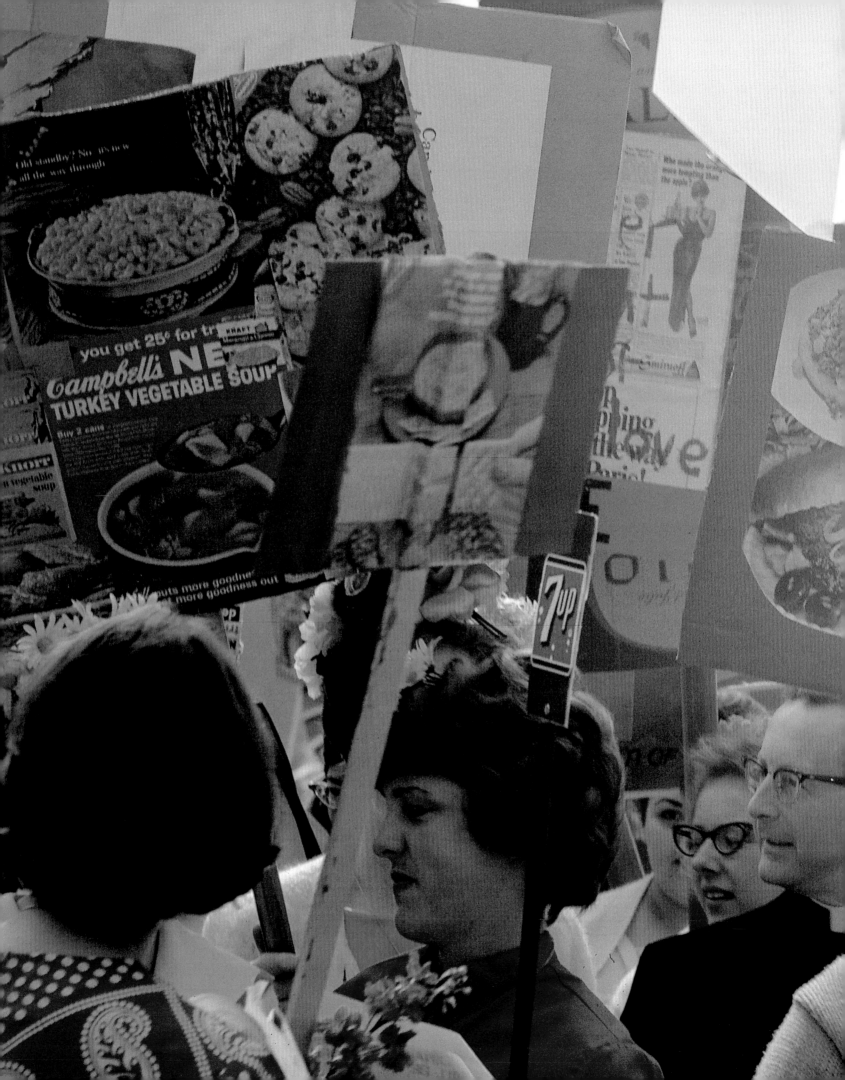

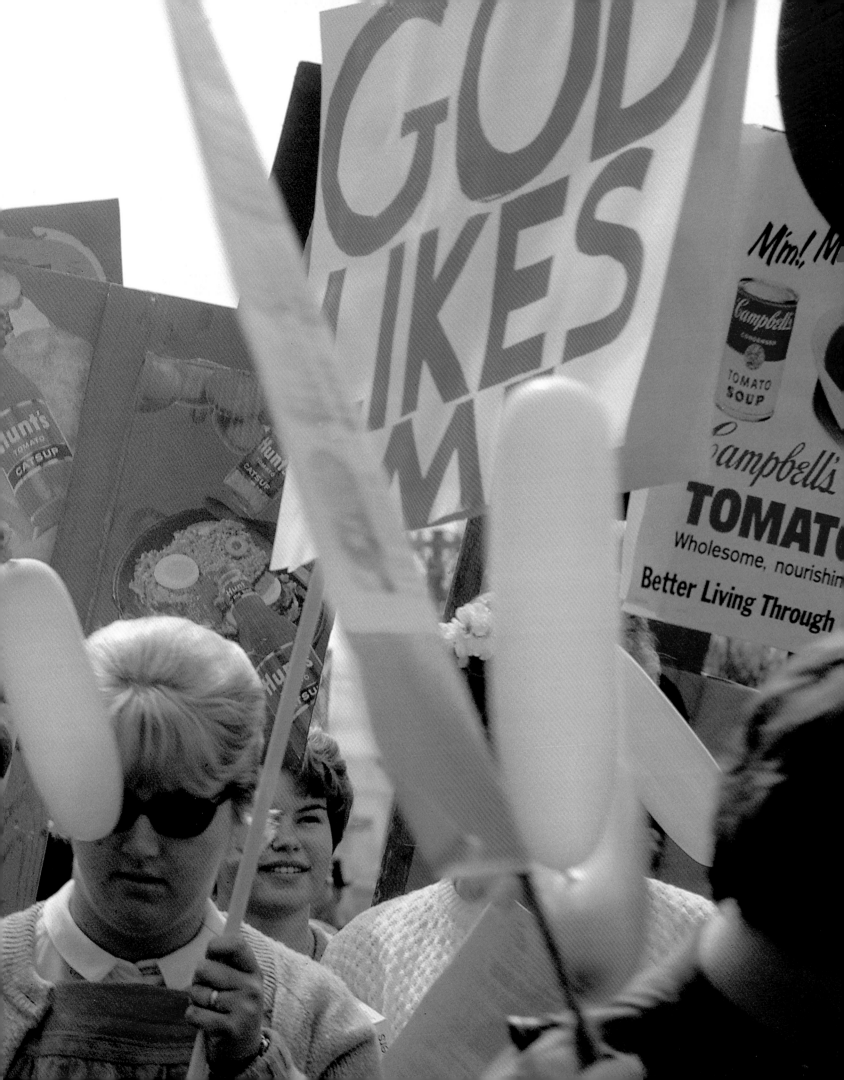

of that theme….students and faculty consider important events and trends of the world they live in. Out of such considerations have come the themes "Food for Peace," "Challenge to Change," and "Revolving." Once a general theme is decided, students begin formulating questions and researching the writings of great philosophers, politicians, theologians, and poets. Then they organize the results of their research into a visually and verbally impact-full presentation.[85]

Though it was unlikely their agenda, the 1964 Mary's Day celebration could not have been a more effective campaign for the explosion of advertising into people's daily environment. In subsequent years, Mary's Day continued its popularity and attracted media attention, including national coverage. *Newsweek* magazine declared that: "…Corita's best medium is people. In 1964, for example, she transformed Immaculate Heart College's staid religious festival, Mary's Day, into a religious happening. With black-robed nuns parading in flowered necklaces, poets declaiming from platforms and painted students dancing in the grass, Mary's Day became a prototype for the hippies' 1967 be-in in San Francisco."[86] Not everyone, however, was enamored; some community members were offended by the disavowal of traditions, such as somber garb and saying the rosary. Criticisms from patrons and the archdiocese reached Helen Kelley.

While 1964 seems to have been the most spectacular, and certainly hard to beat, the following

↓ Interior view at IHC on Mary's Day, 1964
↘ Exterior of IHC, Mary's Day, 1964
↘↘ Box signs, Mary's Day, 1964
→ IHM sisters and art department students visiting Charles and Ray Eames in Pacific Palisades, 1958

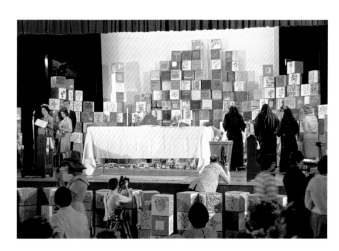

years were also organized by Corita and the department, and thematized around social issues. Constant features, embellished and implemented differently each year, included the use of cardboard boxes as building blocks for setting the scene, the production of placards and signs then carried by participants, banners made by art students, and colorful patterned cloth and clothing worn by participants. Corita explains the impetus for the use of boxes:

We went out to Charles Eames' house one time on a field trip. He had had his grandchildren visiting him, and to entertain them, he had bought them a hundred cartons of about twelve inches square and made marvelous blocks. And then he had a rope hanging from the ceiling with a noose down toward the floor, and you could put your feet in it and swing, pile them up, and knock them all down. But when we brought this class, they all used them to sit on. We were doing boxes for quite a while after that in different ways.[87]

Corita and her students produced a number of large-scale disposable exhibitions that used cardboard boxes as a structuring device – *Peace on Earth*, 1965, and *Survival With Style*, 1966, being the most prominent examples. In the middle of teaching a class one day, Corita received a phone call inviting her to make a Christmas exhibition for the IBM Product Display Center at Madison Avenue and 57th Street in New York. She responded, "we don't have the time – but we'll do

it." There were no strings attached by the company.[88] The Eameses had by this time done several commissions for IBM, including films beginning in 1957 and exhibitions beginning in 1961.[89] Corita turned the invitation into the main work of the semester and the final exam for her lettering and display class. "She divided the class in half to work under two student directors, Mickey Myers and Paula McGowan, 'who are most able to hold up under the strain. It was up to them to create the project and portion out the work,' Sister Corita explained."[90] *Peace on Earth* was one hundred and thirty-three feet long, ten feet high, and six feet deep and was constructed from seven hundred and twenty-five corrugated packing boxes.[91] "We thought: Christmas – peace – peace-making is up to us – how is it made? – how do we do it? – who has already made some? We chose five men – John XXIII, John Kennedy, Nehru, Hammarskjöld, and Stevenson. Each student found sixty statements from the writings of these men that showed how they tried to make peace."[92]

The avant-garde exhibit opened but was abruptly closed by the company until modifications were made to "satisfy IBM officials who thought the original design was not 'Christmas-y' enough and 'might be interpreted as some sort of demonstration about Vietnam.'" "We did some re-arranging and deleting of the material that looked like placard pickets carried in those marches," curator, Robert Monahon said. "One panel that came down was a red, white and blue one, with white stars, that had the word 'Peace'

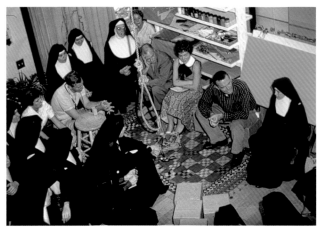

at the bottom."[93] Myers and McGowan, who had installed the exhibit, made the changes, and Corita, who responded to press queries while traveling elsewhere, rejected the idea that the show was censored, saying she didn't want to make a fuss. "It just goes to show the power of words, though doesn't it? I didn't think the messages were that strong, but apparently they are."[94]

Although technically not a corporate commission, the *Peace on Earth* situation, with its zone of compromise encompassing the multiple agendas of Corita, her students, and IBM employees, paved the way for, and predicted, the many corporate commissions Corita was to take on in the following decades. Arguably, corporate sponsorship for art did not have the same inferences of blatant co-optation that it does now. As a willing participant in such exchanges, Corita was in good company alongside artists such as Jim Dine and designers such as the Eameses and George Nelson, who accepted corporate commissions optimistically in order to utilize resources and mass communication venues, and to promote their versions of social responsibility and utopian philosophy. It is interesting to look at Corita's responses to compromise and censorship in context. Though she was certainly beleaguered by, and aggravated with, the repeated censure pressed upon her by the Los Angeles archdiocese in the mid- and late-1960s, her documented response to IBM was lighthearted, as was her approach working elsewhere in the wider world after leaving the Immaculate Heart.

Extending from the *Peace on Earth* project, *Survival With Style*, created the following year, was a disposable exhibition produced over one semester by about thirty-five students for the college, and later shown at the World Council of Churches Assembly in Uppsala, Sweden and the International Congress on Religion, Architecture and the Visual Arts in New York. The exhibition was made from over fifteen hundred cardboard boxes, stacked in configurations to form temporary architectural structures. The boxes composed walls and islands that ultimately produced a maze for viewers to wander through. The boxes cum walls were adorned with bright colored paint, hand-lettered quotations, clippings from newspapers and magazines, graphics, and slogans, resulting in a media-infused and visually dynamic environment.[95]

The Ecstatic Classroom

Corita had a talent for galvanizing students' creative forces and for channeling their energies into ambitious projects requiring tremendous amounts of planning, research, labor, and organization. How did she engender such industriousness? By what means did she stimulate eyes and minds and activate the creative impulse in so many, from young women in daytime courses to men and women of all ages in the extension classes? What educative philosophy and teaching methods did Corita employ? What was the culture of her classroom like?

In her capacity as teacher, and chair of the college's art department from 1964–1968, Corita

← Detail, *Survival With Style*, 1966
↙ Detail of work by David Mekelburg, for Corita class project at the World Council of Churches
↗ *Survival With Style* exhibition, (Corita in reflection), 1966
↘ Slogan, cut-up and recombined by Corita, 1967

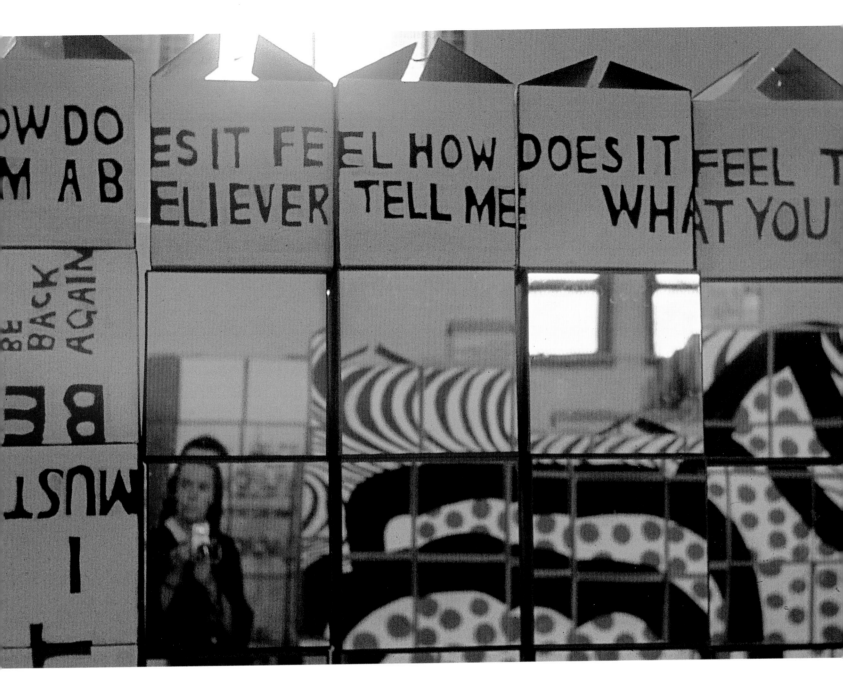

expressed a spirit in step with the widespread critique of authority structures that personified America in the paradigm shift of the 1960s. Corita's classroom, where she taught lettering and layout, image finding, drawing, and art structure,[96] was renowned for its lively interdisciplinary environment, in which multiple films were screened simultaneously, pop music played on the stereo, and large-scale collaborative projects were usually in process.

The art department at Immaculate Heart is a place full of questions, a place whose only answer is really an attitude of openness to and celebration of life. It is part of Sister Corita's teaching method to keep her students constantly struggling with the kind of questions that make them open up to all their experience, sifting it for possible answers. Students live with such questions as "What is a revolution?" "How are food and peace related?"[97]

Corita preached meticulous ways of looking and doing. "Save everything – it might come in handy later." "Look at everything." "Pretend you are a microscope." "Make a movie with your eyes." "Look hard." "Always be around. Come or go to everything. Always go to classes. Read everything you can get your hands on. Look at movies carefully, often." "Don't blink when you're watching a movie or a cut-up page, you may miss some frames which is like missing whole pages from a book." The rules of the IHC art department also reflected Corita's philosophy. Rule Four: "Consider everything an experiment." Rule Six: "Nothing is a mistake. There's no win and no fail. There's only make. Anything that comes your way, including the work of artists, is a place for starting."[98] Corita's proposal that *everything* is potentially motivating must have been tremendously refreshing, liberating students from academic traditions of what art can be, and its accepted forms. The following student, after participating in a workshop with Corita, testifies:

With our textbook ideas about art, we came together this summer, 1958, to find ourselves thrust into a whole new schema of thought. The "lights went out" in all the corridors that were thought to lead to ART and we have been left groping in what we may fear to be the wrong direction....

Our explorations into this new world through creative thinking, coupled with creative doing, in such projects as collages, wall books, posters, and contour drawings left us wondering (in that uncomfortable darkness!). We have been dug out of our complacent, neat little ruts and have been challenged to go beyond the narrow confines of our Puritanical heritage – to plunge – and into a whole wonderful new world of sensitive perceptions.[99]

Corita's philosophy, presence, and style were crucial factors in producing a permissive atmosphere in which people would relax, and gauge their own finding processes and visual fascinations. This environment made space for embracing new ideas and developing creative fluency, independently and

← *Survival With Style* in the making at IHC, 1966
↙ Classroom workshop, IHC, 1966
→ Corita in IHC classroom

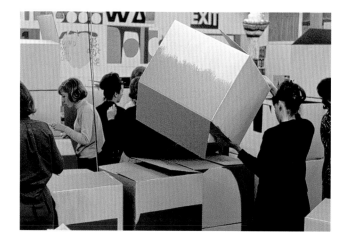

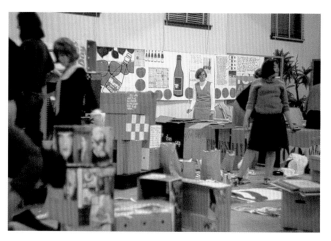

in groups. "In a non-directive teaching method as spontaneous as her style of art, she presents her students with stimuli – records, tapes, photographs, films – without any kind of introduction. In this way she flings them into an exercise of their own judgment, which is what very few people ever learn to do in the visual arts."[100] Attendance was required: "You aren't needed to be there to get grades or pass the course – you are needed to help make the class."[101] Students learned to understand the stakes of self-discipline, that they were responsible not only for their experience and learning, but for the class itself and the caliber of its collective effect.

Corita was a believer in high-volume assignments, what Jan Steward termed "red-eye-specials,"[102] geared to developing observational consciousness and analytic skills. For example, she asked students to select a photograph and then write twenty-five ways the photograph differed from what it recorded. As an exercise, a class, each person with a Coke bottle in front of them, might sit in a circle for an hour, and look at it. Another assignment asked students to list one hundred reasons why they are taking art in a liberal arts college; this "immediately releases the student from the crushing responsibility to produce something great."[103]

…one of the assignments I gave them was when Charles [Eames] first gave us the India film on the exhibit that Alexander Girard did at the Museum of Modern Art. [Textiles and Ornamental Arts of India] I showed them the film, and then afterward I said, "Now, go home and come back tomorrow with two hundred questions about the film." And you find that these things are very difficult to do. The first ten or twenty questions are painful. But after that you get very slaphappy, and you start opening up and expanding. A lot of the questions were worthless, but out of that whole batch, you would get some marvelous things; and, again, the whole process, I think, was a good stretching exercise.[104]

Corita was also an advocate and practitioner of formal experimentation. In Baylis Glascock's vivid documentary film, *Corita Kent: On Teaching and Celebration*, she advises her students never to start a project with a content-driven idea, but to focus first on shapes, colors, or whatever interests them visually, which in the process of engagement, she assures them, will naturally produce content. Work and play were not regarded as mutually exclusive in this set-up. Rule Nine: "Be happy whenever you can manage it. Enjoy yourself. It's lighter than you think."

Corita considered herself more of a teacher than an artist; "I really did art on the side."[105] In fact, the two seem to have been inseparable in her practice. The mutual stimulation and influence flowing between Corita and her students is palpable in their collective artistic output. Many of the projects produced by class groups extend from the sources and methods Corita applied in making her own work. She activated the apprentice system

as an educative structure; therefore it is natural that the artistic manifestations produced remind viewers of Corita's style. However, the giant disposable exhibits and Mary's Day celebrations were the creative work of many; the collaborative process is mirrored in the ambitious, complex results. Of course, not everything in the department was done collectively. Students also conducted independent investigations and made visual art in various media, which Corita consistently documented.

The art department's influence was inspiring in various ways. For years, classes made banners, which in the wider culture were termed "church-style" or "nun-art." The art department staged several banner exhibitions, the most spectacular being in the hall of the National Gallery in Washington, DC, and at the Los Angeles County Museum of Art. Corita commented, "I think the banners really did have a great – well, I would say they had a wide influence, not a great influence. I picked up a little Hallmark book the other day – in fact, somebody sent it to me because they were laughing over it – and as you turn page after page, it looked like stuff that had been thrown away in the art department. It was a very bad copy of almost everything we had ever thought of doing. And I think with the banners, the same thing happened. People have started making banners, but they're dead. They have a kind of nonenthusiasm to them."[106]

Another common activity in the culture of Corita's classroom was making walls and other structures that functioned as scaffolding for students to articulate and contribute parts to.[107] "…a *wall* was any wall-sized picture, combining images and sometimes using words. The size of the wall was determined by the last fraction of available space. Projects at IHC included murals on buildings, Corita's commissions (often done as class projects), theatrical back-drops and time-lines – the wonderful device perfected by Charles and Ray Eames to present a rich accumulation of data in the context of time. Corita used the term *time-line* for any project whose purpose was to show layers of relationships."[108]

When Corita stopped teaching at Immaculate Heart College, she wanted to pass on some of the educative philosophy of the art department, in which "a gifted faculty shone the light of poetry on basic skills and daily living,"[109] and impart ways of working that students had found useful. After ten years went by, she asked her friend and former student, Jan Steward, to collaborate on doing that in book form. The resulting volume, *Learning By Heart. Teaching to Free the Creative Spirit*, is a vibrant textual and pictorial resource that reflects their experiences on how creative impulses are catalyzed, not only for making art, but also in daily life. Divided into sections including Looking, Sources, Structure, Tools and Techniques and Work Play, it is a loaded resource, at once informative, rousing, and playful.

The forms and styles propagated by Corita and the college's art department students do not engender reproductions, copies, and "in the spirit

← The IHC art department rules ↘ *daily*, 1967 → Procession with banners at Watts Towers, Los Angeles, c. 1959

IMMACULATE HEART COLLEGE ART DEPARTMENT RULES

Rule 1 FIND A PLACE YOU TRUST AND THEN TRY TRUSTING IT FOR A WHILE.

Rule 2 GENERAL DUTIES OF A STUDENT: PULL EVERYTHING OUT OF YOUR TEACHER. PULL EVERYTHING OUT OF YOUR FELLOW STUDENTS.

Rule 3 GENERAL DUTIES OF A TEACHER: PULL EVERYTHING OUT OF YOUR STUDENTS.

Rule 4 CONSIDER EVERYTHING AN EXPERIMENT.

Rule 5 BE SELF DISCIPLINED. THIS MEANS FINDING SOMEONE WISE OR SMART AND CHOOSING TO FOLLOW THEM. TO BE DISCIPLINED IS TO FOLLOW IN A GOOD WAY. TO BE SELF DISCIPLINED IS TO FOLLOW IN A BETTER WAY.

Rule 6 NOTHING IS A MISTAKE. THERE'S NO WIN AND NO FAIL. THERE'S ONLY MAKE.

Rule 7 The only rule is work. IF YOU WORK IT WILL LEAD TO SOMETHING. IT'S THE PEOPLE WHO DO ALL OF THE WORK ALL THE TIME WHO EVENTUALLY CATCH ON TO THINGS.

Rule 8 DON'T TRY TO CREATE AND ANALYSE AT THE SAME TIME. THEY'RE DIFFERENT PROCESSES.

Rule 9 BE HAPPY WHENEVER YOU CAN MANAGE IT. ENJOY YOURSELF. IT'S LIGHTER THAN YOU THINK.

Rule 10 "WE'RE BREAKING ALL OF THE RULES. EVEN OUR OWN RULES. AND HOW DO WE DO THAT? BY LEAVING PLENTY OF ROOM FOR X QUANTITIES." JOHN CAGE

HELPFUL HINTS: ALWAYS BE AROUND. COME OR GO TO EVERY-THING. ALWAYS GO TO CLASSES. READ ANYTHING YOU CAN GET YOUR HANDS ON. LOOK AT MOVIES CAREFULLY, OFTEN. SAVE EVERYTHING—IT MIGHT COME IN HANDY LATER. THERE SHOULD BE NEW RULES NEXT WEEK.

of" versions as they once did. But the legacy of Corita's teaching is not only apparent from the artists who emerged from her classroom, but in the fact that many of the women and men who studied with her and other like-minded faculty at the college, have since incorporated the educational principles that fueled those classrooms, gone on to become teachers, and apply and extend such methods in various capacities and settings. In 1972, artist Sister Karen Boccalero, for whom Corita had been both teacher and mentor, founded Self Help Graphics, the grassroots East Los Angeles visual arts institution which, since 1972, has been dedicated to producing, supporting, and exhibiting printmaking and art by Chicano artists.[110] As teacher, Corita seemed to generate an empowerment movement of sorts, profoundly changing people's ways of seeing, thinking, and doing. Steward has said, "She taught with the pull of a strong tide."[111] Many former students cite Corita's teachings as life changing in so far as she attuned their attention to the aesthetics of everyday life and their actions within that, no matter what their activity or profession. This makes sense, given that the art department's motto was, "We have no art, we do everything as well as we can."[112]

After moving to Boston, Corita was invited to teach at Harvard, but declined in favor of a quieter life than she had experienced for the past decade.

Corita had scores of admirers throughout her life, and since her death. Despite such notoriety, her legacy is somewhat marginalized in cultural history. Corita was resolutely unconventional: in the Church her voice was deemed radical, and in the broader contexts of social and political conflicts of the 1960s she was individualistic and unclassifiable. Corita created her own distinct visual language. Still, her work does not fit easily into categories although it has resonance in both art and graphic design. Lorraine Wild has speculated that the term graphic design was not in common use during Corita's era, "…It also may be that her vision of art and design was so inclusive, and focused on that creative process over the final product, that she did not see a need to define what she did as a subset of a general design practice."[113] A number of well-known designers, including Wild and Jeffrey Keedy, as well as artists, including Ed Ruscha and Mike Kelley,[114] express evidence of Corita's influence. However, as a Catholic woman populist printmaker, Corita was rendered secondary status in the art world and her prints have never achieved "fine art" status in the eyes of many curators, art critics and historians. It may well be that the popularity and sentimental currency of Corita's 1970s and 1980s work has undermined her previous work of the 1960s from being properly evaluated and registered as seminal within the canons of pop art.

How did Corita fare on a personal level during the latter part of her life, after leaving the IHC? Did she fashion her life anew? Did she get to work on her art exclusively, as she had desired? Speaking about the changes and joys that came from leaving Los Angeles and moving to Boston,

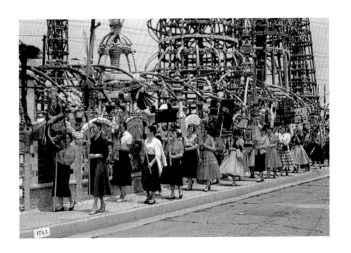

she said, "I make my home which I think of as a large piece of sculpture."[115] And:

I'm learning to sleep now. I just sleep at different times – whenever I feel like it.[116]…I think I have a calmer life, and a chance for more inner development, which I think is not only different but also normal for a person. As you know, as you finish the extreme active part of your life, the part that is outward, you tend then to want to develop what hasn't had a chance yet. And I think I'm having that chance to develop more inwardly than I had before.[117]

Corita's family was very important to her during this period, and her sister, Mary Catherine, largely supplied her support system after she left the convent. Mary founded Corita Prints, located in Los Angeles, and became Corita's manager, as Corita had to make a living for the first time in her life.[118] Although a shift occurred in her art upon relocating to New England, Corita's political convictions as well as her optimism about society carried through her entire life. She contributed prints and designs to numerous political causes, including the George McGovern presidential campaign, Cesar Chavez and the United Farm Workers, the Washington March on Poverty, the Michael Harrington Campaign, and Project Hope. Commissions from various companies and organizations had been a strong component of her career for some time as had designing book jackets for Daniel Berrigan; magazine covers and

↓ Corita, 1976
↘ Computer desk panels and wall hangings, Digital Equipment Corporation, 1978
→ *Love* stamp, 1985, United States Postal Service

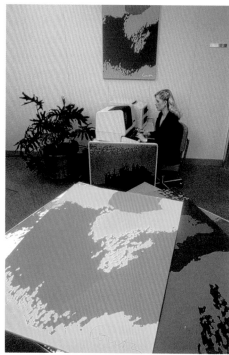

inserts for *Psychology Today* and the *Saturday Evening Post* among others; greeting cards; logos, including that of the World Council of Churches; and other commercial items including a Christmas pattern of Neiman Marcus wrapping paper, a holiday card for Revlon, and the design for a line of Samsonite luggage. After her move, Corita increased the volume of corporate commissions, mystifying some of her friends.[119] She considered the companies she worked with powerful sites for communication and the commissions as opportunities to promote social justice and celebration. From 1966 through the early 1980s she designed ads for Group W (Westinghouse Broadcasting Company), who also published a series of her prints based on a quotation each, used by the company as advertising to spell out their credo, beliefs and practices. She designed computer desk panels and wall hangings for the Digital Equipment Corporation in 1978. Distribution to broad audiences continued to be important for Corita and she remained a popular artist. Corita made several widely circulated books and continued to create between ten and thirty serigraph designs and watercolors each year. Her post-1970 art is perhaps her most well liked, and most purchased. Corita is renowned in the area for adorning the Boston Gas Company's natural gas tank with a hundred and fifty foot rainbow, which quickly became a local icon. And in 1985 the U.S. Postal Authority published her *Love* stamp in an edition of seven hundred million. Corita Kent died the year after.

With enthusiasm and a celebratory position on life, through her teaching and through her art, Corita opened the way for various forms of liberation in the many individuals and institutions she affected over time. Heightened awareness, analytic consciousness, aesthetic innovation, political activism, collaborative spirit, collective experience, visual pleasure, intellectual empowerment, and serious fun are just a few of those forms.

Work was Corita's wellspring. Rule Seven: "The only rule is work. If you work it will lead to something. It's the people who do all of the work all the time who eventually catch on to things." Corita herself is testament to this adage.

Endnotes begin on page 122.

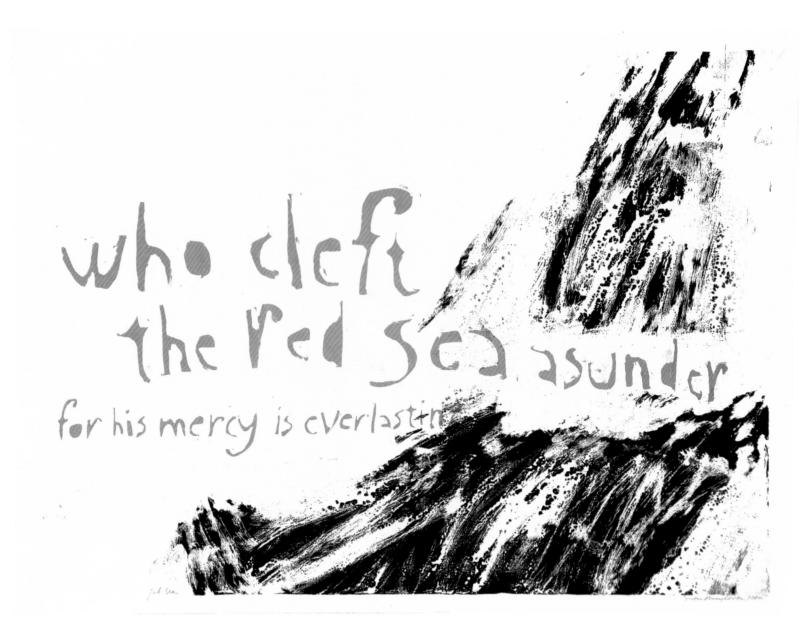

red sea
1959, 24 × 33 in.

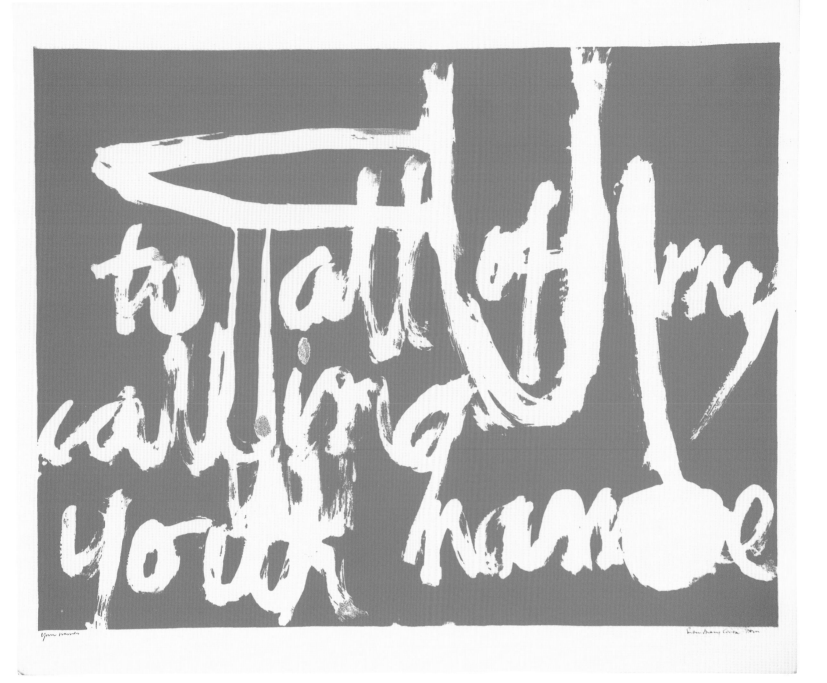

to all of my calling your name
1962, 25½ × 30½ in.

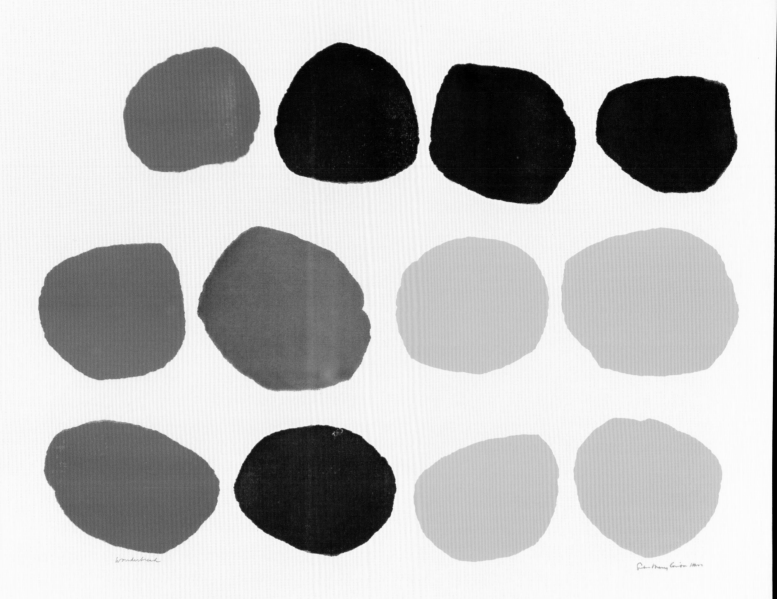

wonderbread
1962, 25 1/2 × 30 1/2 in.

wide open
1964, 29 1/2 × 36 in.

ENRICHED BREAD
WONDER

Great ideas, it has been said, come into the world
as gently as doves. Perhaps then, if we listen attentively,
we shall hear, amid the uproar of empires and nations,
a faint flutter of wings, the gentle stirring of life and hope.
Some will say this hope lies in a nation; others, in a man.

I believe rather that it is awakened, revived, nourished
by millions of solitary individuals whose deeds
and works every day negate frontiers and the crudest
implications of history.
As a result, there shines forth fleetingly
the ever threatened truth that each and every man,
on the foundation of his own sufferings and joys,
builds for all. Camus

helps build strong bodies 12 ways

STANDARD LARGE LOAF

no preservatives added

enriched bread
1965, 29¾ × 36¼ in.

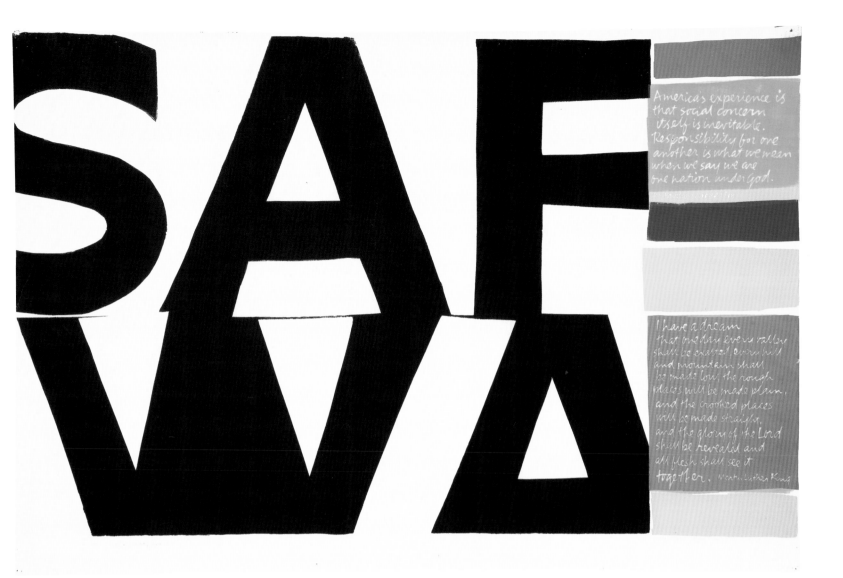

Americas experience is that social concern itself is inevitable. Responsibility for one another is what we mean when we say we are one nation under God.

I have a dream that one day every valley shall be exalted, every hill and mountain shall be made low, the rough places will be made plain, and the crooked places will be made straight, and the glory of the Lord shall be revealed and all flesh shall see it together. Martin Luther King

someday is now
1964, 24 × 36 in.
Next page: *come alive*
1967, 13 × 23 in.

IS
THE
GLORY
OF
GOD

GOD

FULLY
ALIVE

make it

THE
BLUE
CROSS
WAY

IS
VERY SIMPLE

WE
WALK
TOGETHER

THE
GLORY
OF
CHRIST

IS
MAN
FULLY
ALIVE

DON'T
YOU
NEED
SOMEBODY

TO LOVE
?

JEFFERSON
AIR
PLANE

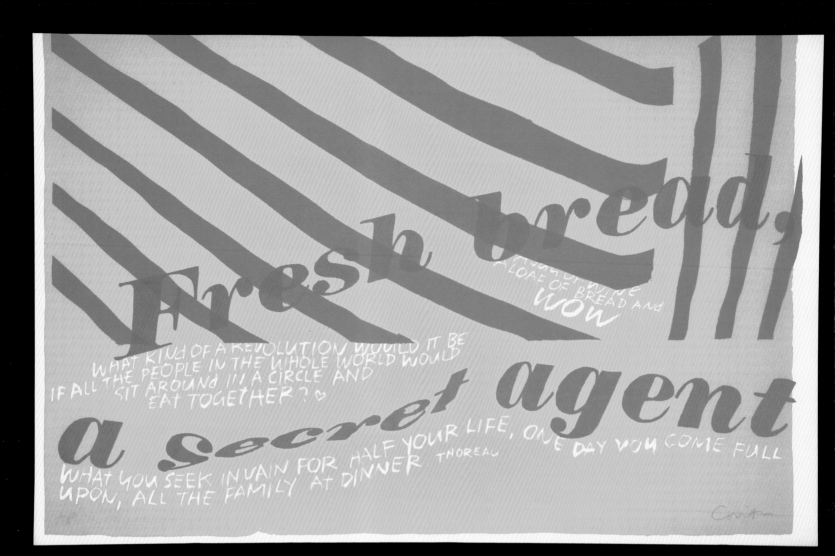

fresh bread
1967, 14 × 22 in.

THE
BIG
STANDS
FOR
GOODN

the time is always
out of joint....

If we are provided with
a sign that
declares.
Del Monte
tomatoes
are juciest"
it is not dese-
cration to add:

A cigarette
commercial
states: "So
round, so firm
so fully packed
and we are
strangely
stirred, even
ashamed as
we are to be so
taken in.

Mary Mother is the juciest
tomato of them all."

Perhaps this is what is meant when
the slang term puts it, "She's a peach,"
or "What a to-
mato!"

We are not
taken in.
We yearn for
the fully pack-
ed, the circle

that is s
ounce m
"groan
with goo
taste, le

e's own ridiculousness, allegory become symbol, wine becom
nd somehow we have been taken from the greedy signs of bea

hole. The rose of all the world becomes, for awhile, and i

he juiciest tomato of all

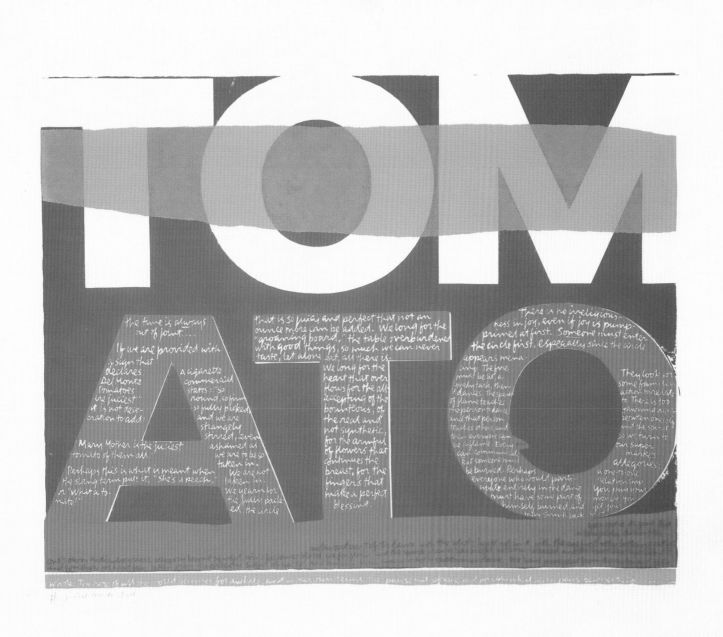

the juiciest tomato of all
1964, 29³/₄ × 36 in.

Lesson NINE

The sun is very full of sunshine
which is very pleasant just at nine,
when the wash is hanging out on
the line. Turkeys are wild a
turkeys are tame which is a s
Peacocks too and then are bl
and if all this is true
who are you.
Thus is what the sun said
when after having been up
since nine he thought of sitting
time after time, but they said no,
what is there to show that the sun
has sunshine if he is setting
all the time. So the sun
he would shine even
if it was nine and he
did just as if he was a
lid which he was be-
cause there was a
cover which did
cover all around the sun cover the sun all up and
after that there was no bother nobody had to get
up even at nine. Anyway there was
no sunshine, not yesterday.

It is different today.
Thank you very much for such. g. stein

TO
FLAVOR
AGAIN
HOME
COME

SO: I SEE YOU - A VERY FRESH UNIQUE, WONDERFUL INDIVIDUAL
WHEN I SEE YOU I CAN BELIEVE IN LOTS OF THINGS: CREATIVITY, INDIVIDUALITY,
HUMANITY, LOVE, RECIPROCITY - WHEN I WRITE, TALK OR THINK ABOUT YOU, CLOUDS LIFT
LIGHT FILTERS THROUGH AND FOR A BRIEF INSTANT, I CAN SEE ALMOST FOREVER

AND THAT'S MORE THAN ANY HUMAN BEING SUCH AS I HAVE A RIGHT
TO: AND TO HAVE IT SO MUCH, SO OFTEN, MAKES ME WANT TO
SAY GRACE ALL DAY LONG. LET NO ONE SPEAK OF
GOD'S DEATH - OR NON-EXISTENCE TO ME WHO HAVE
FOUND HIM IN THIS WONDROUS STRANGE
HAPPENING TO OUT-HAPPEN
ALL HAPPENINGS - OUR MEETING W

I BELIEVE IN ME
THROUGH YOU
BELIEVE IN GOD
THROUGH YOU

I FEEL GOOD IN A
SPECIAL WAY,
I'M IN LOVE,
AND IT'S A SUNNY DAY

HARNESSES
THE SUN TO
POWER THIS

HOW DOES IT FEEL
TO BE ONE OF THE
BEAUTIFUL PEOPLE
? L + M

THE WORLD CANNOT BE WRONG
IF IN THIS WORLD THERE'S YOU

yes people like us
1965, 35 × 28¾ in.

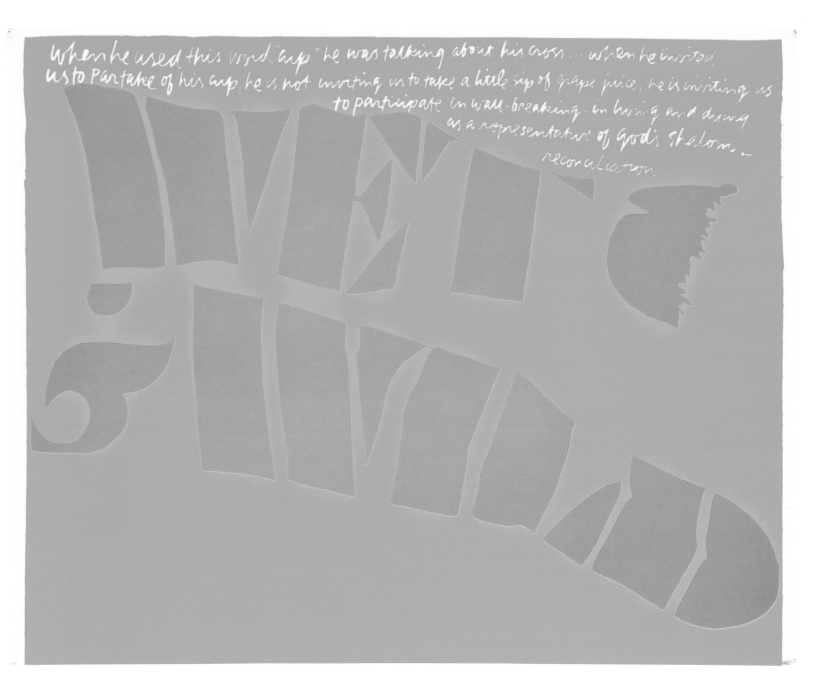

When he used this word "cup" he was talking about his cross... when he invited us to partake of his cup, he is not inviting us to take a little sip of grape juice, he is inviting us to participate in wall-breaking, in living and dying as a representative of God's shalom.. reconciliation

wet and wild
1967, 18 × 23 in.

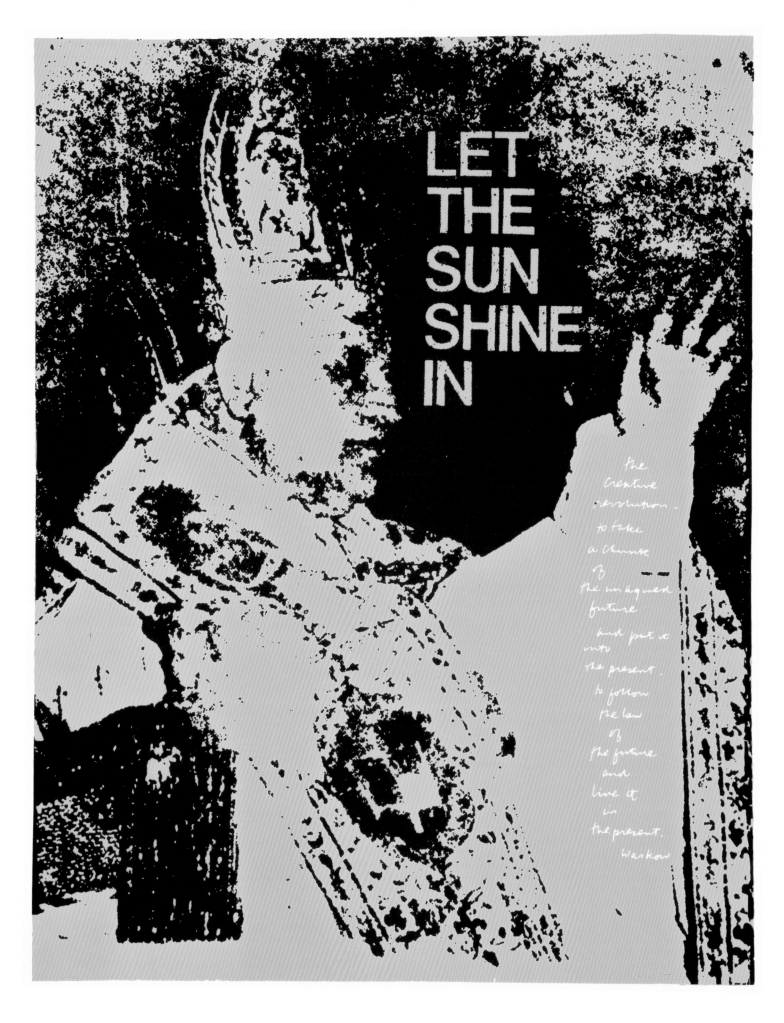

let the sun shine
1968, 29 × 23 in.

SERVIC

k the s

ENTRAN

somebody

brea

rules'

had to

THE
ROSE IS A
ROSE AND W-
AS ALWAYS A ROSE
BUT THE THEORY NOW
GOES THAT THE APPLE'S A ROSE,
AND THE PEAR IS AND SO THE PLUM, I
SUPPOSE. THE DEAR ONLY KNOWS
WHAT WILL NEXT PROVE A ROSE.
YOU OF COURSE ARE A ROSE.
BUT WERE ALWAYS A ROSE.

ROBERT
FROST

somebody had to break the rules
1967, 30 × 36 in.

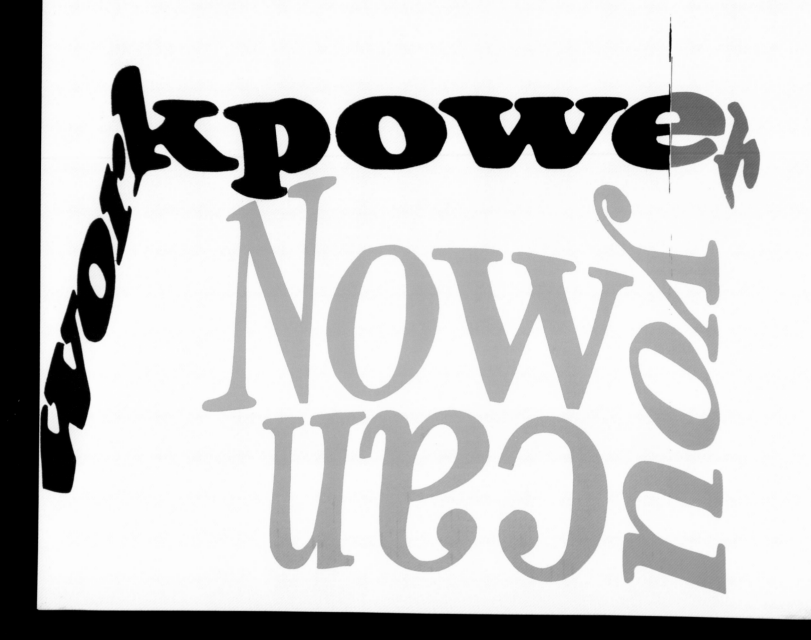

now you can
1966, 30 × 36 in.

I GET by with A Little HELP FROM MY FRIENDS

LENNON + McCArtney

JESUS NEVER FAILS

do

It's got easy

GET WITH THE ACTION

REJOYCES MAN'S HEART

THAT WINE

POWERFUL ENOUGH TO MAKE A DIFFERENCE

SHOULDER SO THEM USE ENOUGH FOR EM

but the
handling
is in your
hands

HUMBLE

RESEARCH WORKS

WONDERS WITH OIL

Tiger

HUMBLE

RESEARCH WORKS
WONDERS WITH OIL
who
cares

we care

we care
1966, 30 × 36 in.

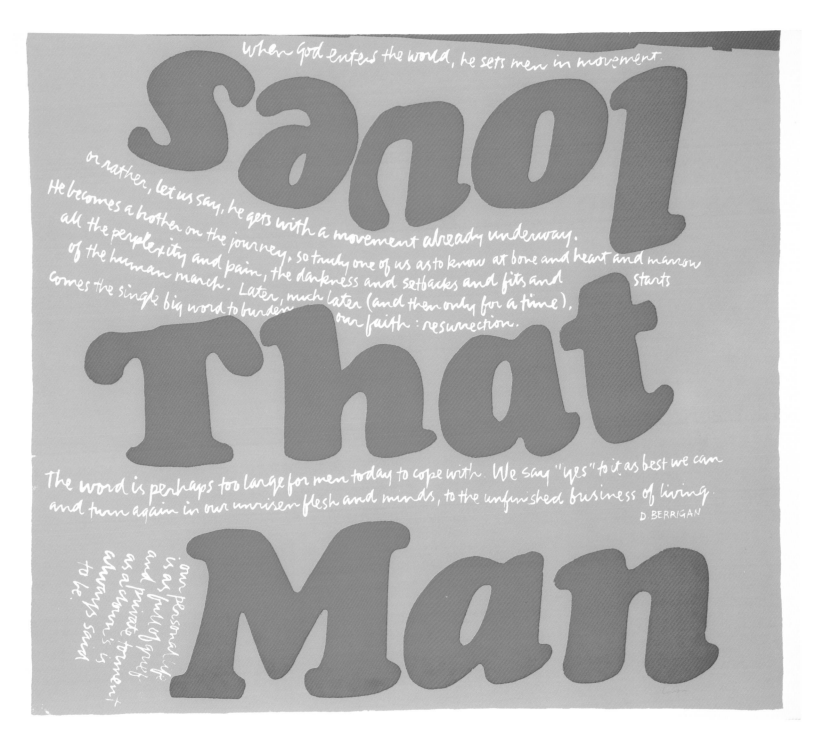

I LOVE THAT MAN

When God enters the world, he sets men in movement.

or rather, let us say, he gets with a movement already underway. He becomes a brother on the journey, so truly one of us as to know at bone and heart and marrow all the perplexity and pain, the darkness and setbacks and fits and starts of the human march. Later, much later (and then only for a time), comes the single big word to burden our faith : resurrection.

The word is perhaps too large for men today to cope with. We say "yes" to it as best we can and turn again in our unrisen flesh and minds, to the unfinished business of living.
D. BERRIGAN

our personal life is as full of grief and private torment as a chemist's always said to be said

that man loves
1967, 19 3/4 × 23 in.

song about the greatness
1964, 29³/₄ × 36 in.

people like us yes
1965, 23 × 35 in.

give the gang our best
1966, 30 × 36 in.

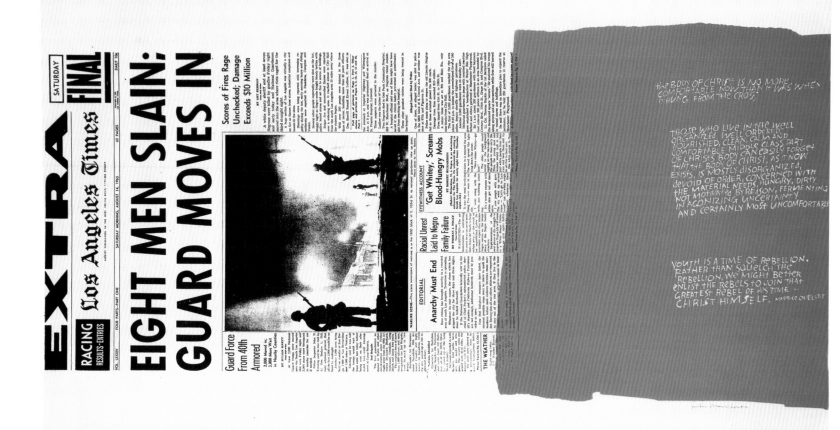

my people
1965, 23 × 35 in.

the BODY OF CHRIST IS NO MORE
COMFORTABLE NOW THAN IT WAS WHEN
IT HUNG FROM THE CROSS

THOSE WHO LIVE IN THE WELL
ORGANIZED, WELL ORDERED,
NOURISHED, CLEAN, CALM AND
COMFORTABLE MIDDLE CLASS PART
OF CHRIST'S BODY CAN EASILY FORGEt
THAT THE BODY OF CHRIST, AS IT NOW
EXISTS, IS MOSTLY DISORGANIZED,
deVOID OF ORDER, CONCERNED WITH
THE MATERIAL NEEDS, HUNGRY, DIRTY,
NOT MOTIVATED BY REASON, FERMENTING
IN AGONIZING UNCERTAINTY
AND CERTAINLY MOST UNCOMFORTAB

YOUTH IS A TIME OF REBELLION.
RATHER THAN SQUELCH THE
REBELLION, WE MIGHT BETTER
ENLIST THE REBELS TO JOIN THAT
GREATEST REBEL OF HIS TIME —

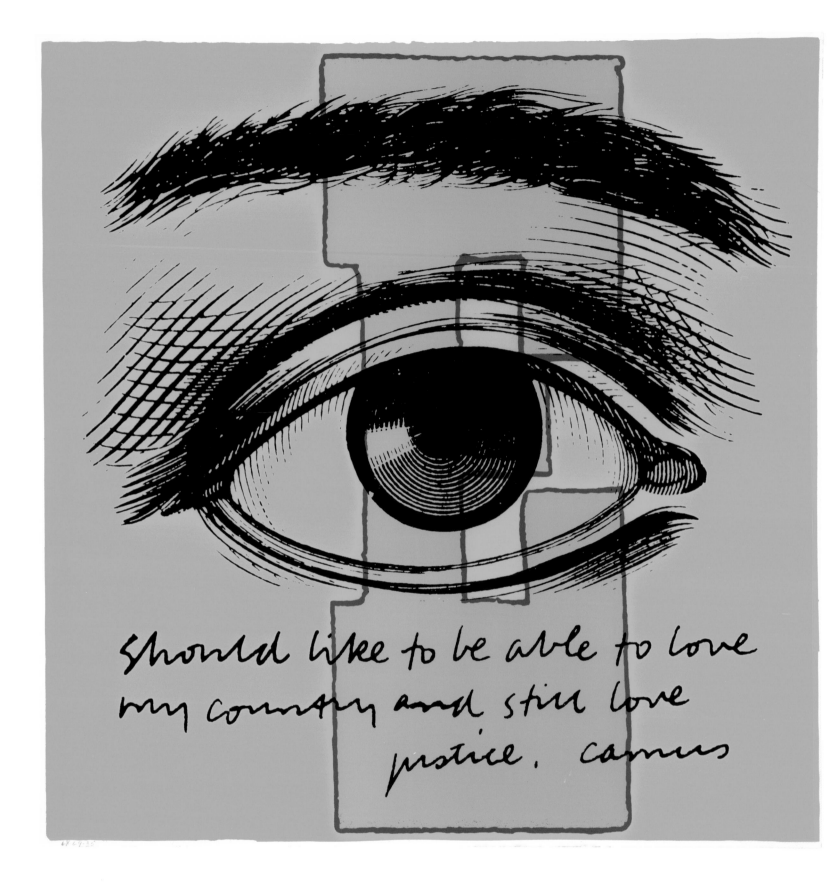

E eye love
1968, 22³/₄ × 22³/₄ in.

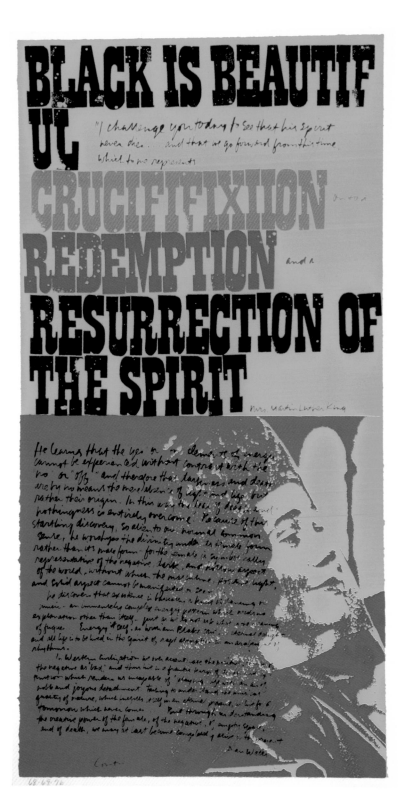

if i
1969, 22½ × 11½ in.

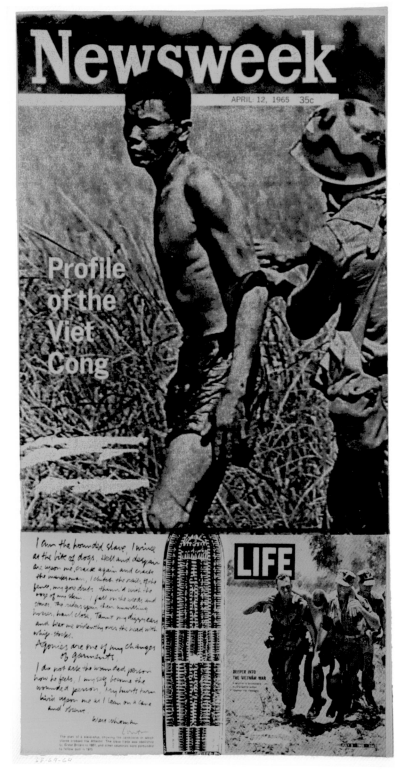

news of the week
1969, 22½ × 11½ in.

who came out of the water
1966, 36 × 30 in.

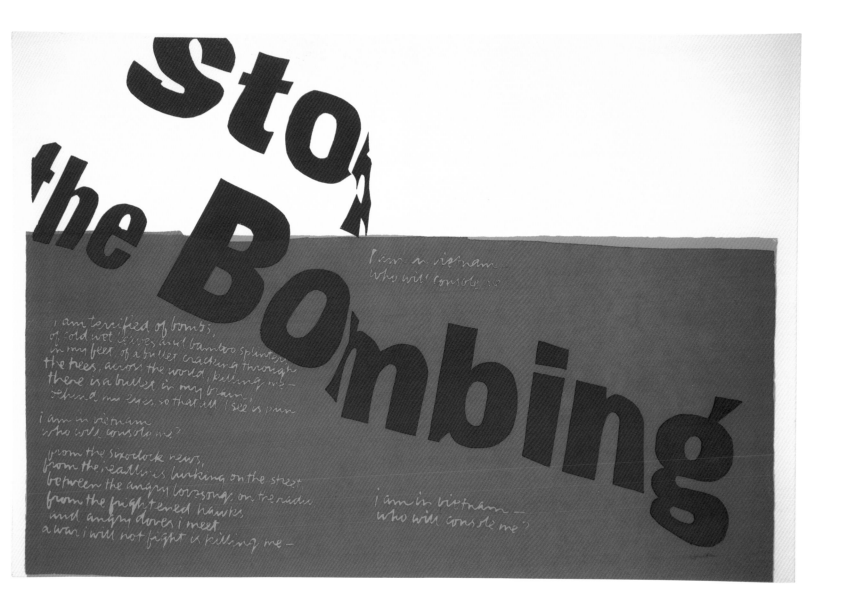

stop the bombing
1967, 15½ × 23 in.

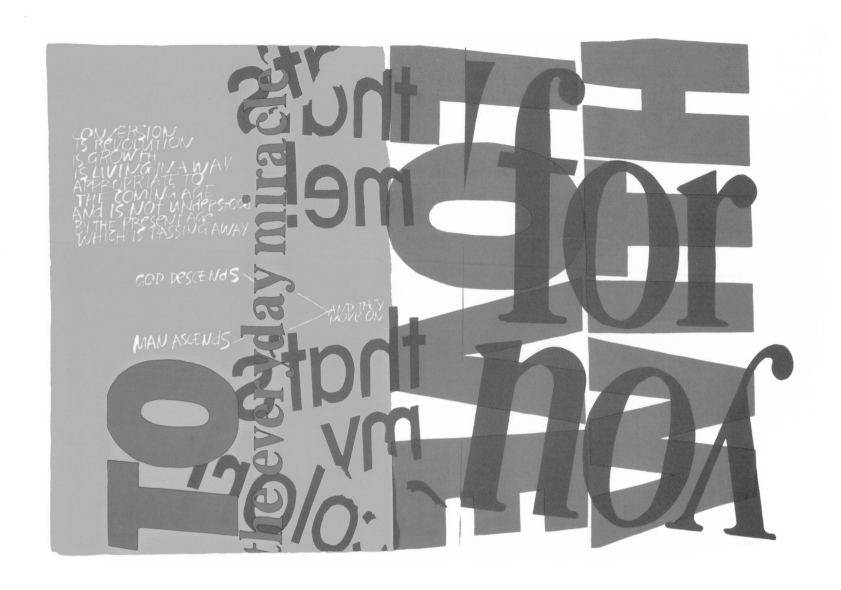

with love to the everyday miracle
1967, 23 × 35 in.

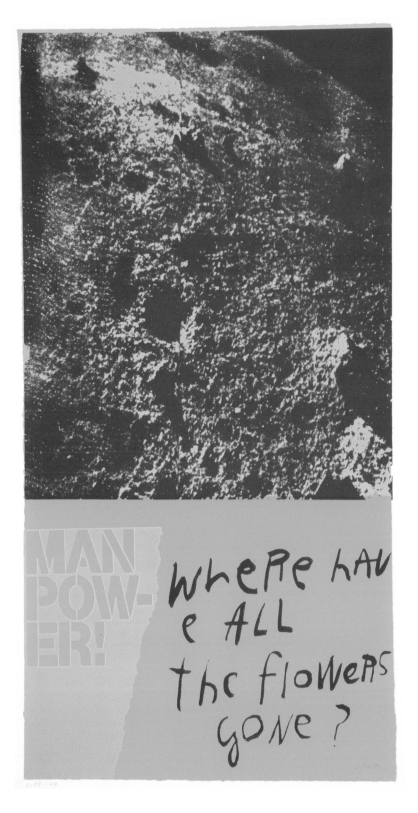

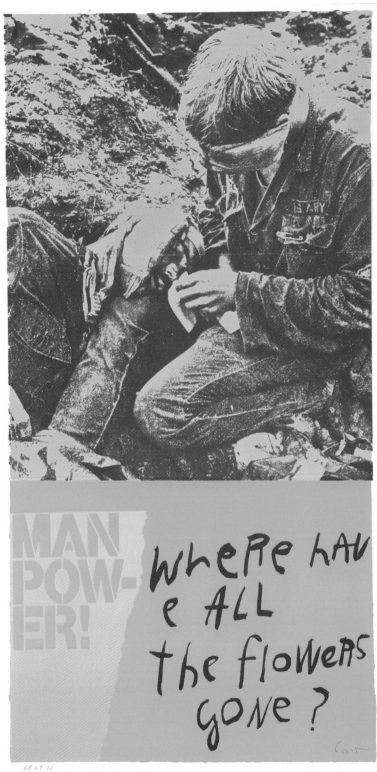

moonflowers
1969, 22 1/2 × 11 1/2 in.

manflowers
1969, 22 1/2 × 11 1/2 in.

RON
WAY
Prophets
of boom

and if only we arrange our life
according to that principle
which counsels us that we must always
hold to the difficult, then that which now
seems to us the most alien will become what we most trust
and find most faithful. How should we
be able to forget those ancient myths that are
at the beginning of all peoples, the myths
about dragons that at the last moment
turn into princesses; perhaps all the dragons
of our lives are princesses who are only waiting

to see us once beautiful
and brave.
Perhaps everything terrible
is in its deepest being
something
that wants help
from us.
Rilke

right
1967, 30 × 36 in.

NO TIME AGO
OR ELSE A LIFE
WALKING IN THE DARK
I MET CHRIST

JESUS) MY HEART
FLOPPED OVER
AND LAY STILL
WHILE HE PASSED (AS

CLOSE AS I'M TO YOU
YES CLOSER
MADE OF NOTHING
EXCEPT LONELINESS

handle with care
1967, 23 × 35 in.

NTLEMAN

T IA

RIE!

MOST

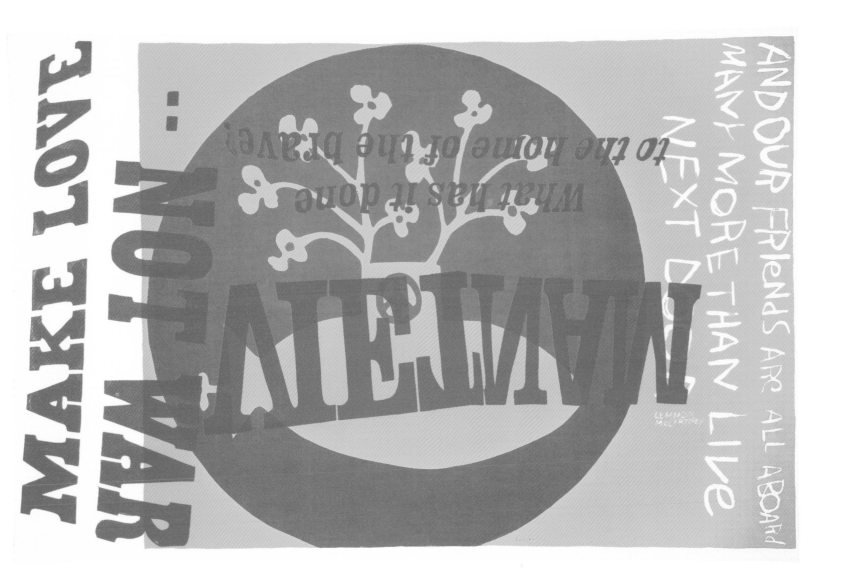

← *american sampler*
1969, 22½ × 11½ in.
↗ *yellow submarine*
1967, 23 × 35 in.

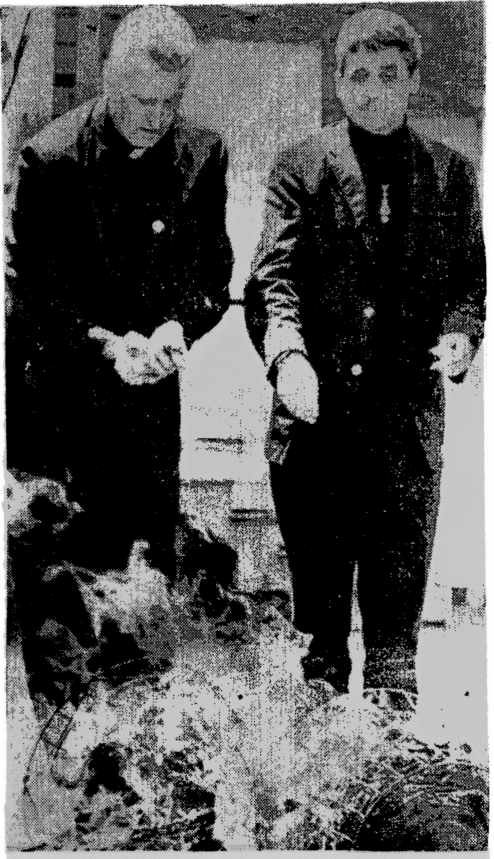

I recall what Thoreau said in his famous essay on civil disobedience,
"under a government which imprisons unjustly, the true place for
a just man is also in prison."
 to me therefore, prison is a very creative way to say yes to life and no to war.
 Thomas Lewis of the Catonsville Nine
They were trying to make an outcry, an anguished outcry, to reach the
American community before it was too late. I think this is an element
of free speech to try – when all else fails – to reach the community

 Kunstler – defense lawyer for Catonsville Nine Conte

← *phil and dan*
1969, 22½ × 11½ in.
↗ *things go better with*
1967, 23 × 35 in.

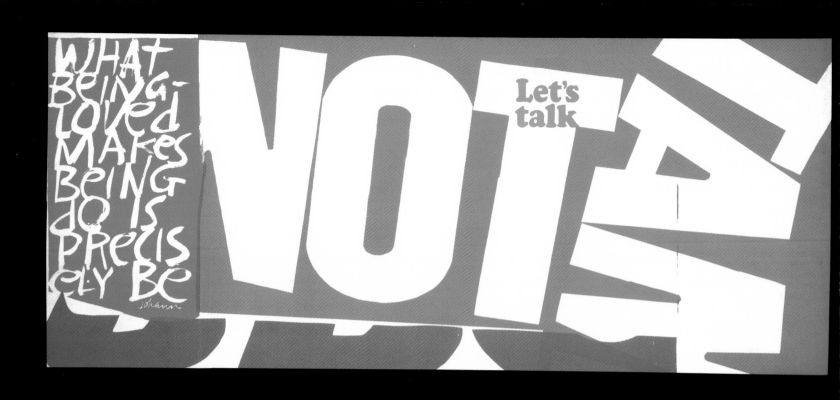

let's talk
1966, 15 × 36 in.

tomorrow the stars
1966, 30 × 36 in.

THE NEGRO AND THE CITIES

**The
Cry
That
Will
Be
Heard**

MARCH 8 · 1968 · 35¢

WHY NOT GIVE A DA MN ABOUT YOUR FELL OW MAN

●GIVE A DAMN

If you'd take the train with me
Uptown through the misery of ghetto
streets in morning light
There's always night.

Take a window seat put down your
times
You can read between the lines
Just meet the faces that you meet beyond
the window's pane
And it might begin to reach you
Now to give a damn about your fellow
man
And it might begin to teach you how
How to give a damn about your fellow
man.

Come and see how well despair
Is nourished by the stifling air
See a photo in the good old stinking
sometime
Suppose the streets were all on fire
The flames like tempers leaping higher
Suppose you lived there all your life
Do you think that you would mind
And it might begin to reach you why we
give a damn about our fellow
And it might begin to teach you how to
give a damn about your fellow man
And it might begin to reach you why
we give a damn.

Put your girl to sleep sometime
With hunger and your other children by
And wonder if you'll share your bed
With something else that must be fed
Cry many steps down the hall
And it might begin to reach you
Now to give a damn about your fellow
man
And it might begin to teach you
How to give a damn about your fellow
man.

FOR (W.E.)

(As recorded by Spanky & Our Gang)
© T-M-C-T
© C7-4307

← *the cry that will be heard*
1969, 22¹/₂ × 11¹/₂ in.
↗ *tender be – part one – sr. william*
1964, 30 × 36 in.

Rest at pale evening...
A tall slim tree...
Night coming tenderly
 Black like me. L. Hughes

I am the man, I suffered, I was there.
I am the hounded slave, I wince
 at the bite of dogs.
I do not ask the wounded person
 how he feels, I myself become
 the wounded person.
All these I feel or am. w. whitman

tender be – part two – sr. william
1964, 30 × 36 in.

help the big bird
1966, 30 × 36 in.

daily
1967, 36 × 30 in.

mary does laugh
1964, 29³/₄ × 39¹/₄ in.

WHEN I HEAR BREAD BREAKING I SEE SOMETHING ELSE; IT SEEMS ALMOST AS THOUGH GOD NEVER MEANT US TO DO ANYTHING ELSE. SO BEAUTIFUL A SOUND THE CRUST BREAKS UP LIKE MANNA AND FALLS ALL OVER EVERYTHING, AND THEN WE EAT; BREAD GETS INSIDE HUMANS.

DANIEL BERRIGAN

bread breaking
1965, 28¼ × 35 in.

left
1967, 30 × 36 in.

The Colors of Corita Kent
by Daniel Berrigan

In 1959, through the good offices of Helen Kelley, president of Immaculate Heart College, I was introduced to the state of mind known as California.

But let me step back a pace or two, and remove my shoes; we are on sacred turf. Our time is the mid-1950s. An east coast bishop, James Francis McIntyre, has been dispatched west, at the behest of our New York king maker, Cardinal Spellman. As shortly became evident, the new archbishop of Los Angeles intended to raise hackles and brows.

While we of the east went about our business in comparative calm and non interference (there was as yet no war in Vietnam to bring matters to a boil), in southern California all was toil and trouble.

Shortly, there was created a species of clerical refugees. The Cuernavaca Center for Latin American Studies, where I was imported from time to time to work with Ivan Illich, offered solace to casualties of the New Ecclesiology of Southern California. A number of North American clerics were suddenly pushed out of Los Angeles, on a road leading anywhere – as long as the road led elsewhere. Some of the exiled priests found work in orphanages and schools and parishes of Mexico. Still others married and returned north to secular jobs. My impression was that those evicted were by and large, talented and devout priests; their loss to the church was a tragedy beyond telling.

Such was the atmosphere, as Immaculate Heart College invited me westward to deliver a public address. The lecture was never given. A day or two before the event, a phone message reached me in New York. It was from president Kelley: Cardinal McIntyre had ordered the lecture cancelled, no reason given. Beyond doubt, as she implied, the dis-scheduled speech was not the point; the speaker was.

And I was not even notorious as yet! When I consider my present disreputable estate vis a vis church and republic, the California episode takes on a loveably archaic look. So large a net cast for so small a fish! I would certainly not qualify at the time as an arsonist of draft files or a jailbird, or

even a renegade from the soporific decencies of academe. Memory summons a rather colorless earnest young cleric with as yet little capacity for trouble making; neither a nose to smell it out, nor the will to set it stirring. Why I asked, this sudden lightning bolt out of a clear sky? A disinvitation, and by decree of a cardinal! The mind boggled.

President Helen Kelley of Immaculate Heart was a very mistress of improvisation; plan B was in her sleeve. The invitation to her campus, she said coolly, was by no means cancelled by this or that byzantine intervention. Would I come to Los Angeles anyway? If so, friends would assemble, making the best of rather straightened circumstance, to our mutual if modest benefit.

So it transpired. Instead of a large lecture hall, our setting was a kind of catacomb; in attendance was a knot of survivors, friends of friends.

There, for the first time, I encountered the Immaculate Heart Sisters, a faculty whose college lay under an ecclesiastical cloud, whose lecturers and guests had, so to speak, to pass through an early warning security system, run by ignorant outsiders. A community that, for a bitter and contentious decade, would be summoned arbitrarily to headquarters, dictated to, scolded, bullied, cribbed and confined.

The sisters were an improbable and varied group; they were talented, vivacious, marked by a democratic, disconcerting sense of dignity and of the consequent rights accruing. Though under considerable duress, they were good humored and calm of mein, skilled in a kind of communitarian patience.

Indeed, as the contest with the cardinal hottened up, it became clear that the sisters had at hand (and heart), resources for a long and bitter haul.

Confronting the sisters were the purveyors of a certain kind of 'ecclesiastical realism.' Among its heady ingredients were money, property, pride of place, strong (male) suppositions as to behavior and attitude befitting or unbefitting; if the latter, to be denounced – or, given plenary offence and absence of remorse, requiring amputation from the church.

The term of contention was implausibly simple. Who was in charge of Immaculate Heart College?

The question bit deep and ranged far. Indeed the stakes were immensely larger than the College. The final prey was the community itself, that seedbed of trouble, 'those women!' Who was to rein in and exact obedience of the community of Immaculate Heart Sisters, dispersed throughout the parochial schools of southern California?

Over the ensuing decade, there settled on the faces of the Immaculate Heart Sisters a look of fixed endurance. Harassment and dictation took their toll. Teaching, running the college in a coherent way, became an extremely penitential exercise.

As may be imagined, the intrusions convulsed the internal life of the community as well. Indeed its members, old and young, vigorous or cautious of mind, endured in a hundred ways the angst that was the common mood of church at war, and nation at war, in the 60s.

Shortly, the world fell apart; for the Sisters of Immaculate Heart, as for me. More nearly, as to Corita.

She was already famous in the early 1950s. The joy in her work, its riotous color, was her gift to a good gray world. It seemed as though in her art the juices of the world were running over, inundating the world, bursting the rotten wineskins of semblance, rote and rot.

It should in plain justice be set down, all she was offering at the time (and continued to offer, despite all) on behalf of the church.

One emotion seemed denied to Catholics; the lack might be thought of as biological, environmental, genetic, a matter of deficient diet or dour instruction, unrelieved by lively season or good sense. Alas, how plumb the heart of that plodding virtuous set-jawed lockstepping bemitred leadership, and the flock that doddered and tottered behind? They needed joy, joy, joy!

Corita Kent had it in abundance. She gave it, pressed down, flowing over. Her art poured out; she was a very witch of invention, holding aloft her cornucopia. The serigraphs hung on the clotheslines drying, in the little back shed where she worked, across the street from the campus of Immaculate Heart College in Los Angeles, where she talked things through, planned, sketched with her students. It was like the mixing room of the hues of creation, colors in combat, contrast, harmony; enough and more for a century of sunrises. Or the room was like the wardrobe of a master clown, if God were a clown – a heresy she seemed secretly, bemusedly, more than lightly inclined toward. Confounding thereby colorless cardinals.

At that time, many of the nuns discarded the old garb. The new costumes were instructive as to personality, dreams, bemusements of the wearers. Corita began to array herself in outrageous nonfashions. She took her lead, by all evidence, from nature, a formerly forbidden ground. Orange boots, wild orange, yellow, plum, cerise gowns.

Was there a message? The gowns were another form of art, celebrational. They were an assault on horizontality, dead weight, dogmatics, liturgy stuck in Dies Irae,[1] the world (the church) as Haceldama. Oh, she was dangerous, that one!

As to her fame, it grew, and yet never seemed to matter. What was she to do with it, this unwieldy baggage of repute? she asked, looking at one with utter insouciance, an innocent in the garden of experience. Fame? The look gave the answer. Why, exactly nothing.

THE COLORS OF CORITA KENT

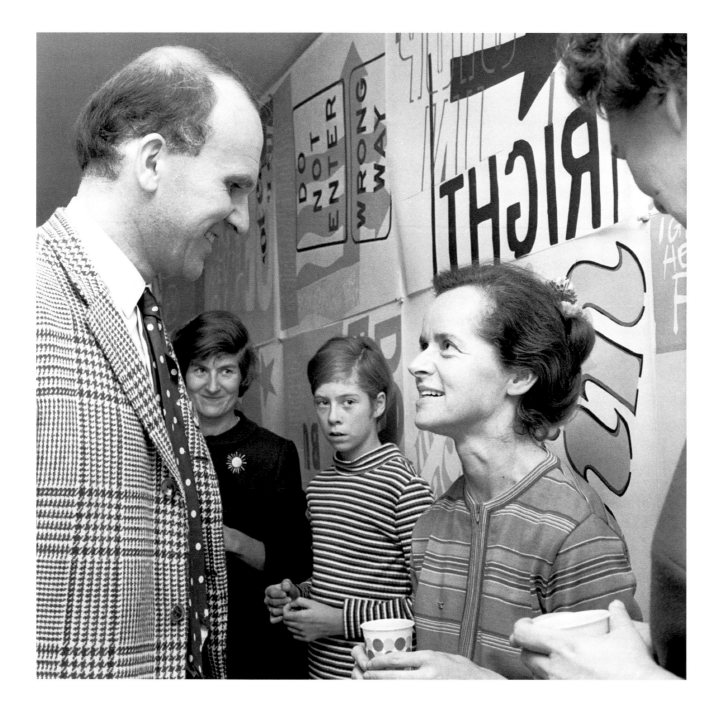

For a period, there was much soul searching in her community, the Sisters of the Immaculate Heart. Nothing like the church militantly in pursuit, one thought, to engender introspection in the hardiest spirits.

They brought in a psychologist for a plenary session. I was ferried westward to join in; on what basis was blessedly unclear. In any case, the meeting of the minds, with the Pacific beating outside the old beach house where we foregathered – the meeting went, in the opinion of a few, from burdensome to nigh intolerable. My sense, obscurely arrived at, was that such dissection, such autopsical pursuits, ought decently to wait on one's decease. One day I fled the premises as quietly as might be, and began walking along the shore. And there, walking toward me, was Corita, likewise fleeing.

Something here, I thought, of the brooding, cherishing, mothering even, of the nest of mystery. We laughed, and let it go at that.

Corita at "An evening with God," The Boston Tea Party, Boston, November 4, 1967

You wouldn't believe it, at first sight. All that savvy and subtlety, the way she absorbed, as though through pores of the soul, the skill of self-concealment. ("She's so NATURAL!" they'd cry.)

She knew more than a few things, and told infinitely less than she knew; what art was, what the art of living was. She made it all look easy. And in a sense, when you thought about it, it was, the art and the living, and the living art she made of it.

You might have thought, if you were not a close friend, that there was no struggle in her life. No contrary winds, no exhaustion from teaching, travel, work, work. No sense of humiliation, no "woman bent double (under the law, that killer) for many years; and doctors hopeless to help." You might have thought, how easily she does it! And how wrong you'd be.

I arrived one Holy Week at the IHC Santa Barbara house to "conduct a retreat." It was that time of century when priests commended to women certain matters of the spirit, more or less evangelically related – (more or less) – matters, which, moreover, the preacher might or might not be thought to exemplify.

Preaching aside, example aside, it was a week that remains green and sunlit in memory. I arrived, to be shown my quarters. And lo, hands, presences, imaginations, had gone before. The walls of my dwelling were inundated, floor to ceiling, in a blaze of Corita serigraphs.

Did they have something in mind, those women? Would the preacher perhaps be enabled, in such a setting, to say something of a Love that bears even with our world, even with the Los Angeles Catholic church?

File under "our world," the news of that week: Holy Week, and the unholy bombing of North Vietnam.

The sisters were preparing the chapel for Holy Thursday, and after that, for the Great Leap of Easter. Whole buckets of orchids began arriving from the neighbors' bounty. One of the sisters asked, "Does your mother like orchids?"

Now in our straitened circumstance of Ol' Clay Farm, where the appearance of a turnip's pate above ground was in the nature of a major breakthrough, what might be called the California Question had not frequently risen.

I swallowed, "I expect she does."

Thus there arrived at my mother's door in Syracuse, New York, on Easter morning, a long elegant box containing, not one or another orchid bloom, but entire sprays of mauve, purple, and white. These were sights not often seen in our northern Appalachian setting.

The day I departed Santa Barbara for New York, the same hands, or others, came to my room, removed the serigraphs with care, packed them up, and presented the bundle. Happy Easter!

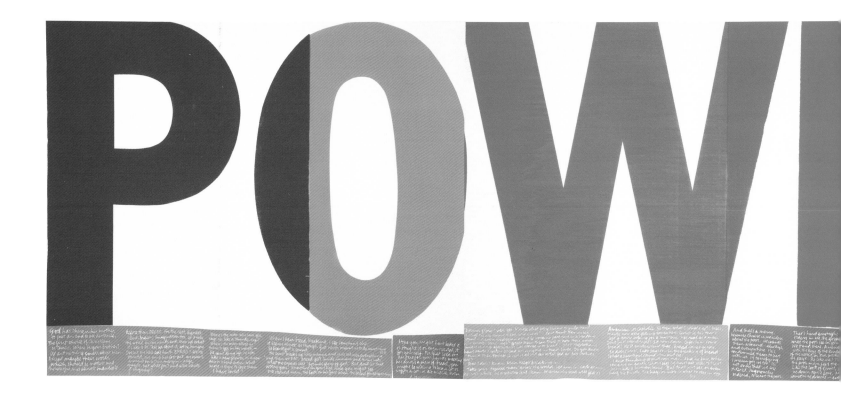

But first, as to Good Friday. As in the first instance, Year One, trouble was brewing. And yet, as the First Instance might have ruefully reflected under Pilate's lash or Herod's scorn – how innocently it all began!

The sisters and I planned a ceremony of reconciliation. It seemed no great matter. Prayers were composed, hymns sung, silence ensued. A sense was conveyed, and more than a sense, that the Lord's death had commended to us what we now commended to one another – the grace of God that renders us gracious.

There were, of course, older, more traditional forms of the sacrament. The sisters, for the most part, preferred the public ceremony of reconciliation. For those who did not, private "confession" was available.

However. Evidently, the group was not entirely composed of pioneers. On my return to New York, I was summoned to Jesuit headquarters. The message concerned a smoke signal from the chancery of Los Angeles. Yours truly had dared conduct a verboten form of the sacrament of penance. A wrist was slapped, dire warnings issued. O Corita!

Her work in the mid and late 1950s was still playfully devotional. "Devotional" was considered befitting. She was after all a nun; her turf was prayer, the saints, Jesus and Mary, the Bible. Nonetheless, it was that persistent playfulness that stuck in gravelly throats. How dare she?

There was the Case of the Notorious Serigraph. It depicted an indubitable, large, rotund – yes, even piggish – tomato. It was overweening in its pop presence; so much had seldom been made of the commonplace. It was as though a whole bushel of tomatoes had incontinently converged in one.

power up
1965, four parts,
28³/4 × 35 in. each

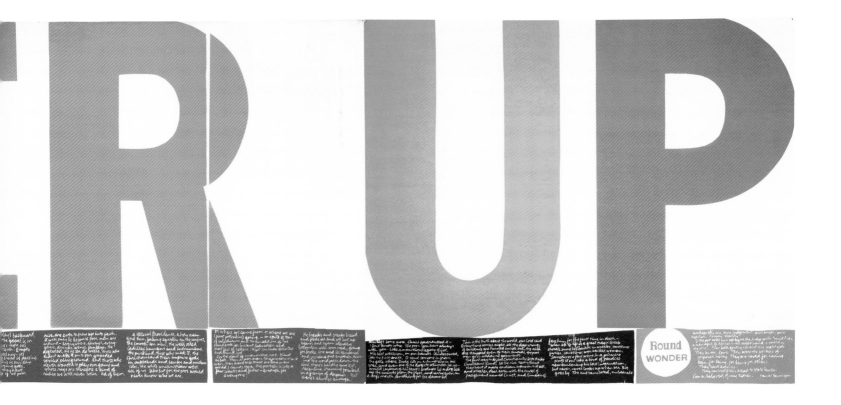

Or as if Corita's elbow had toppled her pot of crimson paint over the paper; as then she decided to make sport of the mishap, rounding things off to a nicety, to a joke.

And then, and then – straight-faced, she scrawled words along the bottom edge, something to the effect of "Mary, the Juiciest Tomato of All"![2]

In a manner of speaking, all hell broke loose.

There were, after all, traditional images of Mary. These had the iconic character of the sacred, out of time, out of place – out of (most of all) youthful hands, playful hands.

There were questions and implications aplenty here, not all of them aesthetic.

Questions like: Who owned the images, anyway?

It was clear, at least it was becoming clearer, especially to women, that the purported owners of the images also placed a heavy hand, a claim, on those who approached the images, those who believed in the presences, those who sought in the icons ways and means of coping, rhythms and beckonings of the human.

Was it to be borne that the human achieve a breakaway, escape custody, scrutiny, no one laying commands, warnings, declaring limits?

There were authorities all over the place (all over the church) raising just such dire possibilities, raising such questions. It was quite simple. They owned the icons, so they defined the human. *In casu*,[3] they said who Mary was, and who she was not.

More to the point, they decreed what metaphors, images, forms, tropes,

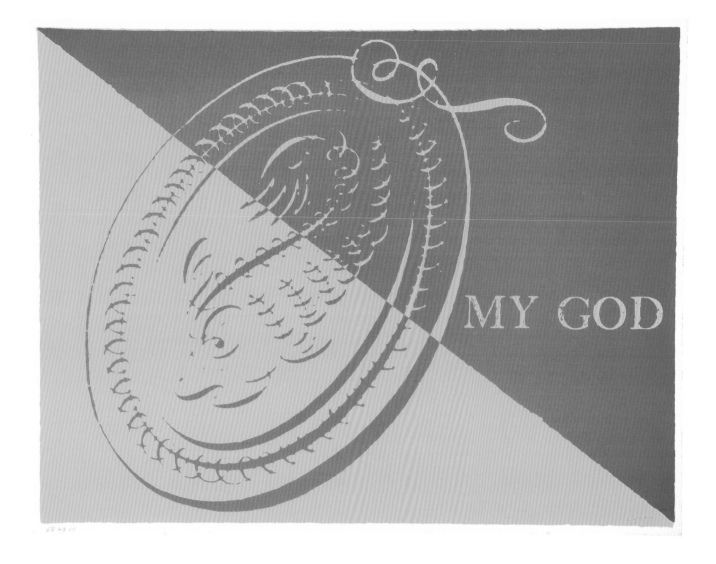

MY GOD

poems, hymns, dances, sculptures – they did the sorting out, sober as a final judgment – which of these befitted and which did not.

This way of proceeding, a favorite tactic in church and state, was inviolate, sanctified (as was decreed by the authorities). Various weighty names were invoked; such and such was "God's will," or indubitably was not. Such and such honored, or dishonored, the saints. The pronouncements had the mordant quality of magic, incantations; they were beyond cavil or reproach, certainly beyond discussion.

Thus in controlling the icons, a powerful aura was created around a certain conception of the human. And this operated with particular force, when the feminine-as-holy was invoked, sculpted, painted, praised, celebrated. Touchy! Who owned the Blessed Virgin?

Well, one thing was clear: Women didn't.

A second thing was clear, clearly a heavenly mandate (to the owners): Men did.

The consequence was weighty indeed. If men owned the icons of the Blessed Virgin, it followed that men had a large say on the subject of women – who they were, how they were to conduct themselves, where and when

o is for god
1968, 17 x 22½ in.

they fitted or exceeded something known in certain circles as "their place."

Would it be intolerable to state the following bit of logic? If men owned the icons of women, men owned women.

Beyond doubt, dynamite dwelt in the images. And to speak of the nefarious Sacred Tomato, it was as though this innocent, Corita, had wantonly planted a charge of dynamite in the fruity heart of things, the ecological original. And then hung around, while a (male) foot (whose else?), provoked beyond bearing, gave the image, so to speak, a vigorous kick – and thereby set off the charge.

I often thought of it. The best weapon was a light touch. The best revenge was an unswipable smile.

She had claimed the icon; reclaimed it, better.

Why get lathered up about such things? A smile of recognition and relief comes to one's face, at thought of her. How guileless she was, and yet how stunningly wise.

Tomato indeed!

She broke the claim, writ on tablets of stone, with the light stave of her innocence.

What's the problem? What's your difficulty? They fumed away, impossible to ignore her, equally impossible to control her.

It was as if the images, noble and precious and under triple lockup, suddenly had been sprung. The doors opened, the holy ones walked free; out of the stale sacristies, away from "close custody."

Corita and I were invited to a Chicago panel. The subject was "religion and the arts." Also summoned was a liberal East Coast bishop, a Bishop Wright, considered at the time a kind of public advocate for lively minds.

The bishop, as became apparent, was leaning toward larger honors. He issued portentous pronunciamentos concerning, well, not much. He would in a season of due ripening, turn red, or rather purple, in visage and raiment.

Corita, nothing daunted, referred to his Eminence mischievously and publicly as "Bishop Wrong." We also discovered a prop which we placed surreptitiously on stage, just before the bishop was to speak. It was a ridiculously elaborate Louis Quinze throne; on it, a mannequin, legs crossed idiotically.

The jest was not well received. Corita predictably took the worst of the riposte. The bishop referred to Lady Bird Johnson's effort to "clean up the billboards that deface public highways." "Alas," he said, "Corita has brought the billboards indoors; she obviously considers them art."

She was diminutive, and in the latter years, frail.

I never saw her angry or out of sorts, though I frequently beheld her in

physical and psychic pain. She seemed constitutionally unable to harbor a grievance.

This is what her friends remember, and mourn – her capacity for friendship, for them.

She knew that the times were a very breaker of bones. Often, friendships tore apart. No point in dwelling on a tragic truism. (Except to dwell on her, and her struggle to remain faithful to her community and those beyond.)

"Those beyond," including myself, never considered ourselves (never were considered) at the periphery of her affection. Did her love for us allow of such an image – periphery, center? We all felt ourselves at center. She made certain we did. She beckoned us there. The gesture was irresistible.

In the 1970s, she accepted work for the great corporations, and a few of us were taken aback, wondering what this might mean. Her designs appeared in the pages of *Newsweek* and *Time*, sometimes double spreads. Was she being taken in? We wondered if anyone was advising her of the activities of these corporate sharks, always anxious to "front" as patrons of the arts, latter-day Maecenases, scattering largesse even as they milked and bilked the world.

At the same time, during those same years, twenty or more, she could be counted on to devote her talents to this or that cause. Thus the posters on behalf of peace, the women's movement, anti-hunger events, ecology. The work was invariably donated.

Images, images. The image maker herself exists in the public image. They "know who she is," it goes without saying. And all wrong, it goes without saying. Nevertheless, she is dealt with mercilessly, arbitrarily, is turned and hefted and tossed about according to the vagaries of public appetite, socialized greed, the preening and scheming.

Who gave a damn about her sense of herself, her dignity, privacy? She must give a damn, and then some; she and a few friends. If they don't persistently, no one will. She (and they, which is to say, we) bid fair to become mere grist for the mills of the demigods, provender of the consumer clutch.

Tread easy. Many have perished without a cry.

Every artist, in a sense, asks for it. The packaging and huckstering of the product includes the image on the wrapping. You, Corita.

By and large, she dealt skillfully with a punishing life. There was something unkillable in her, untouchable even, reserved to a few. *Noli me tangere.*[4] Some tried to own her, and were rebuffed. Her implacable courtesy could turn an assault to a standoff, or better.

Her art followed the course of life, as a shadow follows a form. At the start, she concentrated on images and words drawn from nature and the Bible. (It was a principle she never abandoned that words and images belong together.

Sometimes, not often, the principle got too industrious, plying both sides of the street, so to speak. Then the work reached a point of illegibility.)

In the early fifties, she quickly endeared herself to liturgico-literary middle-professional-Catholics. Her serigraphs illustrated the psalms and prophets and prayers of the church. Her naive eye caught resonances and reflections and hints of the natural world, translated them in a tender wash, just short of sentimental.

And that calligraphy! She drew words rather than wrote them; her brush danced across the page in a lively farandole. The writing was worlds apart from the impersonal ersatz "excellence" of that truly awful "Palmer Method," a form of torture in my childhood. (It occurred to me later that the handwriting corresponded exactly with the theology of *extra ecclesiam nulla salus*.[5])

Corita's script was backhanded, informal, flowing. It was pleasantly offbeat, sophisticated; the scrawl, intermittently legible, of a child who wrote for the fun of it, and was apt to abandon words, as fancy caught, in favor of doodles, stick drawings, or plain daydreaming.

That was her knack: writing that looked improvised, a second thought hurrying after the first. And yet there was seriousness too. In the first years, a word or phrase of scripture set the tone. Later, mockery was often the message. She held up to gentle derision – consumerism, glowing ads for second-rate products, the volatile appetite of the marketplace. And then on to the women's movement, the antiwar movement, billboards, even on a huge gas storage tank in Boston. All grist for the golden mill.

She was neither an art historian nor a philosopher. Her comments on her own work invariably took the form of a gentle nudge toward freedom. Freedom now! The medium was the message.

She saw life as redemptive, rewarding. To her, original sin was, so to speak, a recessive gene. It showed up only in the shadows; its forms were negation, cowardice, self-distrust.

This was where her art came in. Subtly, not so subtly, she kept offering forms of the joy that finally prevails, keeps going. In the face of the sin that says dourly nothing can be done. Or says (the same thing) the church is hopeless, life is a drag, don't bother me, time on my hands.

Corita was in and out of bouts of serious illness for many years. She underwent a wearisome series of operations; she survived, went on with her work. To inquiries about her health, she would say ruefully, things like, "Some of me that was inside me is now outside me."

She would urge me to visit her gallery in New York, near the United Nations, and "choose what you want."

Once in 1981 she gathered her unsold works, made a great roll of them,

sizzling with her colors, and shipped them on. "To make use of as you want. Sell them, give them away."

It was typical of those we love. Some live long, under sentence of death even. And we forget the sentence, the death. We think of them as perpetually in the world, at our side. Fiction? Coping? Something of these.

So in summer of 1986, a friend called. Corita was back in the hospital, surgery again, it looks grim. And I thought, When hasn't it?

It was so grim this time, as to be final. I thought, I must get to Boston.

She had survived the surgery, lost considerable weight, even from that destitute little frame. I found her in a tiny room of an old wing of the hospital. When I came in unannounced, bearing a flowering plant, she broke out weeping. "You make me cry," she said through tears. (She had said to a friend sometime before, "Oh, if I could only weep.")

I said, "I hope you won't have that put on my tombstone, 'I make my friends cry!'" Then she laughed.

We had a good hour together. She was weak as the newborn, but perked up wonderfully for the occasion, very much herself, propped there on pillows, with her own art on the walls, undoubtedly the most cheerful thing her friends could come upon.

We talked and reminisced and wandered far afield in time, calling up friends, occasions, the dreadful years of war when our only recourse, it seemed, was to "have a party," and the only reason to announce one was to plan another.

That was the last visit. A day or two later, she signed herself out of the hospital, and friends took her into their home where she died ever so gently. She left instructions: no funeral. Her friends, she wrote, might decide to gather for a party, that would be just fine.

East Coast and West, they did.

Notes
1 Day of Wrath.
2 This description blends two prints from memory: the first from 1964, which caused the fury, consisted of letterforms spelling the word "tomato" with a lengthy text by Samuel Eisenstein featuring the words, "Mary Mother is the juiciest tomato of them all," and the second from 1967, composed of an image of a Del Monte tomato with a shorter text by Eisenstein, which made no mention of Mary. (Ed.)
3 In this case.
4 Touch me not.
5 There is no salvation outside the Church.

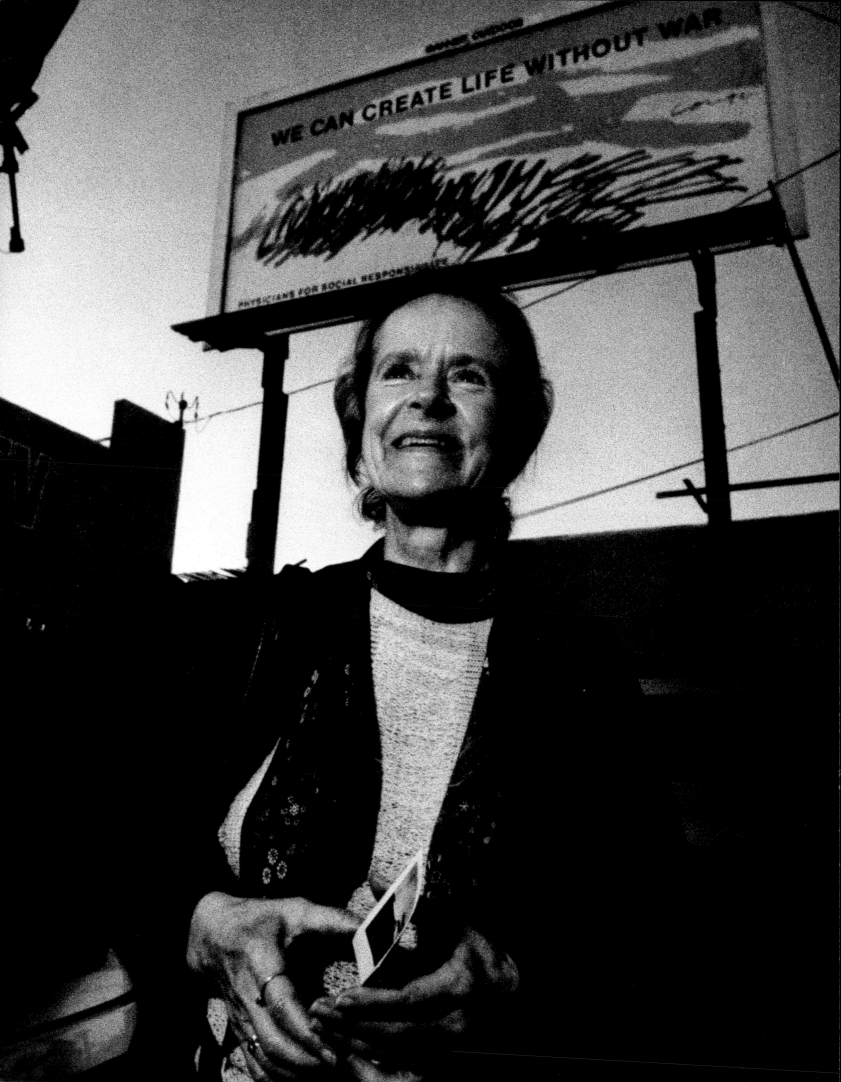

Appendix

What follows is a transcript of the texts in the serigraphs included in this volume. The layout and punctuation of the quoted texts follows that of the original, rather than Corita's transcription, except in the case of *power up*. Very short texts are not included here.

song about the greatness, 1964
Let the ocean thunder with all its waves the world and all who dwell there. The rivers clap their hands, the mountains shout together with joy before the Lord, for he comes.
– Psalm 98.7–9

wide open, 1964
Open wide...that the King of Glory may enter in.
– Psalm 24.9

Open wide the exits from poverty to the children of the poor.
– Lyndon B. Johnson

the juiciest tomato of all, 1964
The time is always out of joint...If we are provided with a sign that declares "Del Monte tomatoes are juiciest," it is not desecration to add: "Mary Mother is the juiciest tomato of them all." Perhaps this is what is meant when the slang term puts it, "She's a peach," or "What a tomato!" A cigarette commercial states: "So round, so firm, so fully packed" and we are strangely stirred, even ashamed as we are to be so taken in. We are not taken in. We yearn for the fully packed, the circle that is so juicy and perfect that not an ounce more can be added. We long for the "groaning board," the table overburdened with good things, so much we can never taste, let alone eat, all there is. We long for the heart that overflows for the all-accepting, of the real and not synthetic, for the armful of flowers that continues the breast, for the fingers that make a perfect blessing.

There is no irreligiousness in joy, even if joy is pump-primed at first. Someone must enter the circle first, especially since the circle appears menacing. The fire must be lit, a lonely task, then it dances. The spark of flame teaches one person to dance and that person teaches others, and then everyone can be a flame. Everyone can communicate. But someone must be burned. Perhaps everyone who would participate entirely in the dance must have some part of himself burned, and may shrink back. They look for some familiar action to relate to. There is too yawning a gulf between oneself and the spirit, so we turn to our supermarkets, allegories; a one-to-one relationship. You pay your money, you get your food, you eat it, it's gone. But intangibly, during the awkward part of the dance, with the whole heart not in it, with the eye furtively looking out for one's own ridiculousness, allegory becomes symbol, wine becomes blood, wafer flesh and the spark flames like bright balloons released, and the "heart leaps up to behold," and somehow we have been taken from the greedy signs of barter and buying, from supermarket to supermundane. We have proceeded from the awkward to the whole. The rose of all the world becomes, for awhile, and in our own terms, the "pause that refreshes," and possibly what was a pause becomes the life.
– Samuel A. Eisenstein

tender be – part one – sr. william, 1964
So yes, I think Mary laughed out loud – she laughed wholeheartedly, without rancor, and with great compassion, and with real reverence. If she were here today in her physical nature she would surely laugh. She would laugh at our wreaths; she would laugh at our pop art; she would laugh – compassionately – at the consternation of some of us at this riot of sound and color, at our uncertainty about its suitability for a day of religious celebration. Frankly, I think Mary would want this day, that she would like to think that it was well explained by calling it her day. She is the cause of our joy – and I hope that we bring her joy by praising her with our hearts on high. If we were only loud and bright, perhaps we could hope only for the indulgent smile of the mother of very small children. Our colors, however are the colors of the marketplace, the colors of life-giving food, and our sounds are the sounds of the here and now, and they are meant to say: mother, I am concerned for my brother, who is your son. My brother starves, he weeps, he dies. He is myself. Today is a loud call to our mother asking her to teach us what she knows of filling the emptiness, drying the tears, and easing the death of our brother. We ask to be taken out of ourselves (this is the whole burden of "Pacem in Terris").
– Sr. William (Helen Kelley) on Mary's Day 1964

tender be – part two – sr. william, 1964
Rest at pale evening...
A tall, slim tree...
Night coming tenderly
Black like me.
– Langston Hughes, "Dream Variations"
(From *The Collected Poems of Langston Hughes*, published by Alfred A. Knopf, a division of Random House, Inc.)

I am the man, I suffer'd, I was there....
I am the hounded slave, I wince at the bite of the dogs...
I do not ask the wounded person how he feels, I myself become the wounded person....
All these I feel or am.
– Walt Whitman, "Song of Myself"

mary does laugh, 1964
Mary does laugh, and she sings and runs and wears bright orange. Today she'd probably do her shopping at the Market Basket.
– Marcia Petty

someday is now, 1964
America's experience is that social concern itself is inevitable. Responsibility for one another is what we mean when we say we are one nation under God.
– Unidentified author, U.S. Pavilion, World's Fair

I have a dream that one day every valley shall be exalted, every hill and mountain shall be made low, the rough places will be made plain, and the crooked places will be made straight, and the glory of the Lord shall be revealed, and all flesh shall see it together.
– Martin Luther King, Jr.

enriched bread, 1965
Great ideas, it has been said, come into the world as gently as doves. Perhaps then, if we listen attentively, we shall hear, amid the uproar of empires and nations, a faint flutter of wings, the gentle stirring of life and hope. Some will say that this hope lies in a nation; others, in a man. I believe rather that it is awakened, revived, nourished by millions of solitary individuals whose deeds and works every day negate frontiers and the crudest implications of history. As a result, there shines forth fleetingly the ever threatened truth that each and every man, on the foundation of his own sufferings and joys, builds for all.
– Albert Camus "Create Dangerously"
(From *Resistance, Rebellion, and Death*, translated by Justin O'Brien, published by Alfred A. Knopf, and copyright © 1960 by Alfred A. Knopf, a division of Random House, Inc., and © Editions Gallimard, Paris.)

my people, 1965
The body of Christ is no more comfortable now than it was when it hung from the cross.

Those who live in the well organized, well ordered, nourished, clean, calm and comfortable middle-class part of Christ's body can easily forget that the body of Christ, as it now exists, is mostly disorganized, devoid of order, concerned with the material needs, hungry, dirty, not motivated by reason, fermenting in agonizing uncertainty and certainly most uncomfortable.

Youth is a time of rebellion. Rather than squelch the rebellion, we might better enlist the rebels to join that greatest rebel of his time – Christ himself.
– Maurice Ouellet

bread breaking, 1965
When I hear bread breaking I see something else; it seems almost as though God never meant us to do anything else. So beautiful a sound, the crust breaks up like manna and falls all over everything, and then we eat; bread gets inside humans.
– Daniel Berrigan

people like us yes, 1965
Text by Maurice Ouellet, as quoted in *my people* (above).

power up, 1965
God has chosen his mother to put an end to all distance. The first choice of Christians is Christ. Where is your brother? Want nothing small about men. Except maybe their words, which should be modest and thoughtful and almost inaudible before their DEEDS. For the rest, bigness; heart, brain; Imagination too; let it take the world in two hands and show us what it's like to BE! Tell us about it, we're hungry. Doesn't the Bible call truth BREAD? We're starved, our smile has lost out, we crawl around on a thin margin – a life, maybe, but what for? And who wants it anyway?

Where's the man who says yes, and says no, like a thunderclap? Where's the man whose no turns to yes in his mouth – he can't deny life, he asks like a new flower or a new day or a hero even; what more is there to love than I have loved?

When I hear bread breaking, I see something else; it seems almost as though god never meant us to do anything else. So beautiful a sound, the crust breaks like manna and falls all over everything, and then we EAT; bread gets inside humans and turns into what the experts call "formal glory of god." But don't let that worry you. Sometime in your life, hope you might see one starved man, the look on his face when the bread finally arrives.

Hope you might have baked it or bought it

or even needed it for yourself. For the look on his face for your hands meeting his across a piece of bread, you might be willing to lose a lot or suffer a lot – or die a little, even.

"Formal glory," well yes. Maybe what we're trying to understand is what they're trying to say, who knows? I don't think they understand – or every theologian would be working part time in a breadline. Who knows. Who might greet them there or how their words might change afterwards like stones into bread? Most theologians have never broken bread for anyone in their lives. Do you know, I think they think Christ is as well fed as his statues are?

But I don't know. Man keeps breaking in.

Take your "typical man" across the world. Let him in. Look at him, he isn't white, he probably isn't clean. He certainly isn't fed or American, or Catholic. So then what? What's left? Well, maybe now we're getting somewhere; Christ is ALL that's left if you're looking for a mystery. He's real as a man. Don't just stand there! Sit him down. Offer him some bread! He'll understand that; bread comes across. So does Christ; Luke says so – in the breaking of the bread. What a beautiful sound – try and see!

I keep thinking of that poor man. And his face, when someone on earth shows up against all odds to treat him like a human being. But that isn't all, or even half the truth. The half, or more, is what he sees is you.

And that's a mercy, because Christ is merciless about the poor. He wants them around – always, and everywhere. He's condemned them to live with us. It's terrifying. I mean for us too. It's not only that we are ordered, rigorously ordered, to serve the poor. That's hard enough; Christ gives so few orders in all the gospel. But the point is, what the poor see in us – and don't see, too. We stand there, American, white, Catholic, with the keys of the kingdom and the keys of the world in our pocket. Everything about us says: Be like me! I've got it made. But the poor man sees the emperor – naked. Like the look of Christ, the poor man strips us down to the bone. And then if we're lucky something dawns – even on us.

Why, we're the poor. The reel plays backward, everything's reversed when the gospel is in the air. The clothes fly off Dives, he's negro, he's nothing, he's got his hand out forever. Empty as a turned up skull. Watch the reel now – it's important to see which way the bread is passing. To you, to me! We're in luck. This is our day.

The poor have it hard, the saying goes. Well, we're the hardest thing they have. Do you know I think sometime if we poor rich are ever going to grow up into faith, it will only be because poor men are around – everywhere, always, everywhere, drunks, winos, junkeys, the defeated, the ne'er do wells, those who didn't make it on to our guarded spoiled playground. And those who never wanted to play our game and whose rags are therefore a kind of riches we will never wear. All of them, a special Providence, a holy rain and sun, falling equably on the unjust, the smooth con men, the well oiled Cadillac humans and inhumans, the purblind, those who made it, the Christians and their impure Gods in cupboards and banks and nuclear silos, the white unchristian west, all of us. Who but for the poor would never know who we are, or where we came

from or where we are (just possibly) going – in spite of tons of catechisms and the ten editions of the Handbook for Instant Salvation and the best of sellers, I Kept You Know Who Out and Found god.

On the cloud of unknowing; hog Blind as bats. Then a poor man (they are all miracle men, they have to be to live one day in our world) stands there. His poverty is like a few loaves and fishes – enough for everyone!

He breaks and breaks bread and feeds us and we live up again and again literally bottomless with sour need, going for broke, sore and ill tempered and jostling one another, hearing the word pass down the line, there's hardly any left, resenting straining forward in a frenzy of despair. But there's always enough, always some more. Christ guarantees it – I Don't know why. The poor you have always with you. Like a marvelous legacy of god. His best possession, in our hands. Undeserved, like the Eucharist. O send someone in from the gate where Dives sits on a dungheap in his sores, send even one of the dogs to whimper for us – would Lazarus of his heart's goodness let a dog lick up the crumbs from the floor, and carry even in a dog's mouth something for the damned.

This is the truth about the world, our Lord said. Everything comes right, all the deep wrongs of existence are turned inside out, the rich are stripped even of their shrouds, the poor men go in wedding garments.

The first way to defeat Christianity is to strike the Christians blind. Let the rich really think they have made it and can hang on to it all, and wheeler deal even with the angel of judgement named Christ, and (imagine) face him for the first time in death – when all of life is a great tragic Greek chorale sung by Christs in masks, sometimes furies, sometimes racked women. Sometimes a foul wino in a pismire sings it out like a bird of paradise remembering his last incarnation, but never, never looks up when Mr. Big goes by. The untranslated, unbearable unbearable cry, pure judgement, pure anger, pure rejection. Reality! Reality!

O the poor will line up before the Judge with Torrid Eyes, a handful of daisies in His right hand, a sword in the other. They look gently toward His right side. They know. Come. They were the workers of corporal mercy. They are saved for having been, for being, for being others.

They save even us.

They carried fresh bread to stale lives.

Come, beloved of my Father.

– Daniel Berrigan

lesson nine, 1966

The sun is very full of sunshine which is very pleasant just at nine, when the wash is hanging out on the line. Turkeys are wild and turkeys are tame which is a shame. Peacocks too and they are blue and if all this is true who are you. This is what the sun said when after having been up since nine he thought of setting time after time, but they said no, what is there to show that the sun has sunshine if he is setting all the time. So the sun said he would shine even if it was nine and he did just as if he was a lid which he was because there was a cover which did cover all around the sun cover the sun all up and after that there was no bother nobody had to get up even at nine. Anyway there was no sunshine, not yesterday. It is different today. Thank you very much for such.

– Gertrude Stein

stop the bombing, 1967

I am in Vietnam
who will console me?

I am terrified of bombs,
of cold wet leaves and bamboo splinters
in my feet, of a bullet cracking through
the trees, across the world, killing me –
there is a bullet in my brain,
behind my eyes, so that all I see is pain

I am in Vietnam
who will console me?

from the six o'clock news,
from the headlines lurking on the street,
between the angry love songs on the radio,
from the frightened hawks
and angry doves I meet,
a war I will not fight is killing me –

I am in Vietnam
who will console me?
– Gerald Huckaby, "I am in Vietnam"

greetings, 1967

When I hear bread breaking, I see something else; it seems almost as though God never meant us to do anything else. So beautiful a sound, the crust breaks like manna and falls all over everything, and then we eat; bread gets inside humans. Sometime in your life, hope you might see one starved man, the look on his face when the bread finally arrives. Hope you might have baked it or bought it or even needed it for your self. For the look on his face for your hands meeting his across a piece of bread, you might be willing to lose a lot or suffer a lot – or die a little, even.
– Daniel Berrigan

right, 1967

And if only we arrange our life according to that principle which counsels us that we must always hold to the difficult, then that which now seems to us the most alien will become what we most trust and find most faithful. How should we be able to forget those ancient myths that are at the beginning of all peoples, the myths about dragons that at the last moment turn into princesses; perhaps all the dragons of our lives are princesses who are only waiting to see us once beautiful and brave. Perhaps everything terrible is in its deepest being something that wants help from us.
– Rainer Maria Rilke, "Letter Eight," Letters To A Young Poet

somebody had to break the rules, 1967

The rose is a rose,
And was always a rose.
But the theory now goes
That the apple's a rose,
And the pear is, and so's
The plum, I suppose.
The dear only knows
What will next prove a rose.
You, of course, are a rose –
But were always a rose.
– Robert Frost, "The Rose Family"
("The Rose Family" from THE POETRY OF ROBERT FROST, edited by Edward Connery Lathem, © Copyright 1928, 1969 by Henry Holt and Company. © Copyright 1956 by Robert Frost. Reprinted by permission of Henry Holt and Company LLC. Published in the UK by Jonathan Cape. Reprinted by permission of The Random House Group Ltd.)

fresh bread, 1967
A jug of wine a loaf of bread and WOW.
– Unidentified author

What kind of a revolution would it be if all the people in the whole world would sit around in a circle and eat together?
– Unidentified author

What you seek in vain for half your life, one day you come full upon, all the family at dinner.
– Henry David Thoreau

handle with care, 1967
no time ago
or else a life
walking in the dark
i met christ

jesus)my heart
flopped over
and lay still
while he passed(as

close as i'm to you
yes closer
made of nothing
except loneliness
– E.E. Cummings, "no time ago"
("no time ago" is reprinted from *COMPLETE POEMS 1904–1962*, by E.E. Cummings, edited by George J. Firmage, by permission of W.W. Norton & Company. © Copyright 1991 by the Trustees for the E.E. Cummings Trust and George James Firmage.)

There is only one man.
– Unidentified author

harness the sun, 1967
So: I see you – a very fresh, unique, wonderful individual. When I see you I can believe in lots of things: creativity, individuality, humanity, love, reciprocity – when I write, talk or think about you, clouds lift, light filters through and for a brief instant, I can see almost forever. And that's more than any human being such as I have a right to: and to have it so much, so often, makes me want to say grace all day long. Let no one speak of God's death – or non-existence to me who have found him in this wondrous strange happening to out-happen all happenings – our meeting. I believe in me through you – I believe in God through you.
– Unidentified author

I feel good in a special way
I'm in love and it's a sunny day.
– John Lennon & Paul McCartney, "Good Day Sunshine"

The world cannot be wrong
If in this world there's you.
– Charlie Chaplin, "This Is My Song"

How does it feel to be one of the beautiful people?
– John Lennon & Paul McCartney, "Baby You're A Rich Man"

things go better with, 1967
What men need today is faith in themselves and in others, release from the sense of their isolation and hope: a conviction that realities like justice, peace, unity and love, are not merely good things on paper, good things in songs, good things meant for the good alone. What men need is a reminder that these

things are worth being born for…indeed that we were born for nothing else…
– Daniel Berrigan

with love to the everyday miracle, 1967
Conversion
is revolution
is growth
is living in a way
appropriate to
the coming age
and is not understood
by the present age
which is passing away
God descends, man ascends,
and they move on.
– Unidentified author

yellow submarine, 1967
And our friends are all on board
Many more of them live next door
– John Lennon & Paul McCartney, "Yellow Submarine"[1]

wet and wild, 1967
When he used this word "cup" he was talking about his cross…when he invited us to partake of his cup, he is not inviting us to take a little sip of grape juice, he is inviting us to participate in wall-breaking, in living and dying as a representative of God's shalom – reconciliation.
– Unidentified author

jesus never fails, 1967
I get by with a little help from my friends
– John Lennon & Paul McCartney, "With A Little Help From My Friends"

come alive, 1967
The glory of Christ is man fully alive. Man fully alive is the glory of God.
– Unidentified author

The blue cross way is very simple, we walk together.
– Unidentified author

Don't you need somebody to love?
– Jefferson Airplane, "Don't You Want Somebody To Love?"

that man loves, 1967
When God enters the world, he sets men in movement. Or rather, let us say, he gets with a movement already underway. He becomes a brother on the journey, so truly one of us as to know at bone and heart and marrow all the perplexity and pain, the darkness and setbacks and fits and starts of the human march. Later, much later, (and then only for a time), comes the single big word to burden our faith: resurrection. The word is perhaps too large for men today to cope with. We say "yes" to it as best we can and turn again in our unrisen flesh and minds, to the unfinished business of living.
– Daniel Berrigan

Our personal life is as full of grief and private torment as a clown's is always said to be.
– Unidentified author

let the sun shine, 1968
The creative revolution – to take a chunk of the imagined future and put it into the present – to follow the law of the future and live it in the present.
– Rabbi Arthur Waskow

news of the week, 1969
I am the hounded slave, I wince at the bite of the dogs,
Hell and despair are upon me, crack and again crack the marksmen,
I clutch the rails of the fence, my gore dribs, thinn'd with the ooze of my skin,
I fall on the weeds and stones,
The riders spur their unwilling horses, haul close,
Taunt my dizzy ears and beat me violently over the head with whip-stocks.

Agonies are one of my changes of garments,
I do not ask the wounded person how he feels, I myself become the wounded person,
My hurts turn livid upon me as I lean on a cane and observe.
– Walt Whitman, "Song Of Myself"

The plan of a slave ship, showing the conditions in which slaves crossed the Atlantic. The slave trade was abolished by Great Britain in 1807, and other countries were persuaded to follow suit in 1815.
– Illustration caption

DEEPER INTO THE VIETNAM WAR:
A Marine is evacuated during patrol action against the Vietcong.
– *Life* magazine caption, July 2, 1965

phil and dan, 1969
I recall what Thoreau said in his famous essay on civil disobedience, "under a government which imprisons unjustly, the true place for a just man is also in prison." To me therefore, prison is a very creative way to say yes to life and not to war.
– Thomas Lewis[2]

They were trying to make an outcry,
an anguished outcry to reach the American community before it was too late. I think this is an element of free speech to try – when all else fails – to reach the community.
– William Kunstler[3]

if i, 1969
I challenge you today to see that his spirit never dies…and that we go forward from this time, which to me represents crucifixion on to a redemption and a resurrection of the spirit.
– Coretta Scott King[4]

He learns that the "yes" or "on" elements of energy cannot be experienced without contrast with the "no" or "off," and therefore that darkness and death are by no means the mere absence of light and life, but rather their origin. In this way the fear of death and nothingness is entirely overcome.
 Because of this startling discovery, so alien to the normal common sense, he worships the divinity under its female form rather than its male form – for the female is symbolically representative of the negative, dark, and hollow aspect of the world, without which the masculine, positive, light, and solid aspect cannot be manifested or seen…he discovers that existence is basically a kind of dancing or music – an immensely complex energy pattern which needs no explanation other than itself – just as we do not ask what is the *meaning* of fugues…Energy itself, as William Blake said, is eternal delight – and all life is to be lived in the spirit of rapt absorption in an arabesque of rhythms…[In] Western Civilization…we over accentuate the positive, think of the negative

as "bad," and thus live in a frantic terror of death and extinction which renders us incapable of "playing" life with a noble and joyous detachment. Failing to understand the musical quality of nature, which fulfills itself in an eternal present, we live for a tomorrow which never comes....But through understanding the creative power of the female, of the negative, of empty space, and of death, we may at least become completely alive in the present.
– Alan Watts, "On the Tantra"
(From *CLOUD-HIDDEN, WHEREABOUTS UNKNOWN* by Alan Watts, copyright © 1968, 1970, 1971, 1973 by Alan Watts, renewed by Joan Watts. Used by permission of Pantheon Books, a division of Random House, Inc. and by the permission of Russell & Volkening as agents for the author.)

the cry that will be heard, 1969
Or put your girl to sleep sometime
With rats instead of nursery rhymes,
With hunger and your other children
By her side.
And wonder if you'll share your bed
With something else that must be fed,
For fear may lie beside you
Or it may sleep down the hall.

And it might begin to teach you
How to give a damn about your fellow man.

Come and see how well despair
Is seasoned by the stifling air
See your ghetto in the good old
Sizzling summertime.
Suppose the streets were all on fire,
The flames like tempers leaping higher,
Suppose you'd lived there all your life,
D' you think that you would mind?

And it might begin to reach you
Why I gave a damn about my fellow man,
And I might begin to teach you
How to give a damn about your fellow man.
– Stuart Scharf and Robert Dorough,
("Give A Damn" (As recorded by Spanky & Our Gang / Mercury)
© Copyright 1968 Takya Music Inc.
© Copyright 1996 Stuart Scharf Publishing.
All rights reserved.)

Notes
1 This appears in the serigraph as "Many more than live next door."
2 Thomas Lewis was one of the Catonsville Nine.
3 William Kunstler was the defense lawyer for the Catonsville Nine.
4 Coretta Scott King, after the death of her husband Martin Luther King, Jr.

Endnotes

The Spirited Art of Sister Corita
by Julie Ault.

This essay draws on ideas expressed in my earlier writings and exhibitions about Corita:

"Archives in Practice," *Interarchive. Archival Practices and Sites in the Contemporary Art Field*, edited by Beatrice von Bismarck et al., (Cologne: Verlag der Buchhandlung Walter König, 2002); reprinted in Julie Ault, Martin Beck, *Critical Condition, Selected Texts in Dialogue* (Essen: Kokerei Zollverein / Zeitgenössische Kunst und Kritik, 2003), 267–278.

Julie Ault and Martin Beck, "All you need is love: pictures, words and worship by Corita Kent," *Eye* 35/00, spring 2000. Special thanks to Martin Beck for allowing me to draw on ideas developed in this essay, 48–57.

"Building and Unbuilding," in *Covering the Room: 8 Ausstellungsflächen*, edited by Florian Pumhösl and Mathias Dusini, (Salzburg and Vienna: Salzburger Kunstverein and Montage, 1998), 44–50.

Power Up, Reassembled (Los Angeles: UCLA Hammer Museum, 2000), exhibition brochure, n.p.; reprinted in Julie Ault, Martin Beck, *Critical Condition, Selected Texts in Dialogue* (Essen: Kokerei Zollverein / Zeitgenössische Kunst und Kritik, 2003), 367–375.

"Somebody had to break the rules," in *springer* Bd. III Heft 4, winter 1997, 42–44.

Power Up: Reassembled Speech, Interlocking, Sister Corita and Donald Moffett (Hartford, CT: Wadsworth Atheneum, 1997), exhibition brochure, n.p.

1 In the existing public record, Corita reflected in 1976, "Because I had never thought of leaving up till that point, so I wasn't having any difficulty with the thought. But after I left, I looked back. And I've never had any regrets about leaving, even though there have been difficulties." Kent, Corita. *Los Angeles Art Community: Group Portrait, Corita Kent*. Transcript of oral history conducted in 1976 by Bernard Galm. Collection 300/157. Department of Special Collections, Charles E. Young Research Library, University of California, Los Angeles, 149. Despite this statement, Corita was likely to have given her decision prior consideration and may have had sight of, or known, her intentions privately. Jan Steward and Corita had abstractly discussed "leaving" when they said goodbye for that summer. Corita referenced their conversation in a postcard she sent to Jan after she had moved. Jan Steward, correspondence with the author, June 2006.

2 All of the newspaper accounts I came across that covered Corita's resignation cite this quote.

3 Sister Corita graced the cover of the December 25, 1967 issue of *Newsweek*, which read, "The Nun: Going Modern," and announced the feature article inside, Kenneth Woodward, "The Nun: A Joyous Revolution."

4 A culturally rich and seemingly innocuous list, conservative critics regarded some of the "Great Men," as morally tainted and accused them of being "communists."

5 Kent, *Los Angeles Art Community: Group Portrait, Corita Kent*, 24.

6 Dan Paulos quoted in Barbara Marianne Loste, *Life Stories of Artist Corita Kent (1918–1986): Her Spirit, Her Art, The Woman Within*, Dissertation submitted for the degree of Doctor of Philosophy in Educational Leadership, School of Education, Gonzaga University, March 2000, 53.

7 See for instance the play based on review of the public record, including Corita's personal papers, and many interviews the writer conducted with Corita's friends, colleagues, and former students: Irene O'Garden, *Little Heart*, 2005.

8 National publications that featured coverage of Corita, or invited her to contribute art inserts, included *Newsweek*, *Look*, the *Saturday Evening Post*, the *Los Angeles Times*, the *Boston Globe*, the *Boston Herald*, the *New York Times*, *The New Yorker*, the *Washington Post*, the *Chicago Tribune*, *Harper's Bazaar*, *Women's World*, *The Lamp*, *The Catholic Voice* and many other local as well as Catholic publications.

9 Loste, 121.

10 Pamela Rothon, "A Conversation with Corita Kent," *TheAmericanWay*, November 1970, 9.

11 Loste, 164. Corita had previous teaching appointments in southern California and taught for five years in Vancouver, but taught at the college for approximately twenty-three years, from 1945–1968.

12 Kent, *Los Angeles Art Community: Group Portrait, Corita Kent*, 21.

13 Jan Steward, correspondence with the author, June 2006.

14 *Irregular Bulletin #13*, Immaculate Heart College art department, December 1958, n.p.

15 Rothon, 11.

16 Mickey Myers vividly recalls those periods, "It was always August, the hottest time of the year in LA, and that confined cinderblock studio was not air conditioned, and the sun beat down on the plate glass windows along Franklin...There was Corita in her habit – the whole bloody habit – woolen scapular, and starched coif, and two layers of veil, and long indigo woolen dress, pulling a three-foot long squeegee that took strength and muscle to pull evenly, especially when you were printing prints that were large and the color coverage was solid. She did all the printing herself, pulling that squeegee thirty prints times one hundred images times how ever many colors there were in each print...There were other sisters helping her, and some friends who came all the way across the country, and everyone had their job...And it smelled, of paint thinner and the awful thick, heavy smell of silkscreen paint, and transparent base... The more she printed, the more it smelled,

until the air was so thick with the fumes and the exhaust and the sweat of summer, that I am told lunchtime was a heavenly relief, back at the convent. But I think the most important thing about this scene is that everyone who was there, wanted to be there…" (Myers, in correspondence with the author, June 2006.)

17 "Peace on Earth," *The New Yorker*, January 1, 1966.

18 Kent, *Los Angeles Art Community: Group Portrait, Corita Kent*, 100.

19 O'Garden, n.p.

20 Loste, 66.

21 Corita kept that name after leaving the order, because she preferred it to her given name, Frances Kent. Mary Seth, "Corita says, 'To Create is to relate.'" *Presbyterian Life*, April 15, 1968. No doubt another factor was that her artistic reputation had been made with the name Corita.

22 Kent, *Los Angeles Art Community: Group Portrait, Corita Kent*, 145.

23 Quoted in Loste, 110.

24 "Fighting Nuns," *Newsweek*, April 1, 1968, 100.

25 Anita Caspary was president of Immaculate Heart College from 1958–1963, followed by Helen Kelley, who was college president from 1963 to 1977. Caspary was mother superior of the community from 1963 to 1969, and was the first president of the new lay community, when the Immaculate Heart Community members were no longer nuns, between 1969 and 1973.

26 Loste, 110.

27 The mural, *The Beatitudes*, was one of the fifteen exhibits in the Vatican Pavilion. According to the pavilion guidebook, "The eight evidences of blessedness or happiness, known as 'The Beatitudes,' form the background for an interesting interplay of quotations from two men named John, Pope John XXIII and John F. Kennedy, in the forty-foot painting on the left gallery wall by Sister Mary Corita, IHM."

28 Kenneth Woodward, "The Nun: A Joyous Revolution," *Newsweek*, December 25, 1967, 46.

29 Henry Seldis and John Dart, "Sister Corita, Noted 'Op-Pop' Artist, Quits Religious Order," *Los Angeles Times*, November 22, 1968.

30 Helen Kelley, IHM, "Highlights of the Immaculate Heart Community History," n.p.

31 "Fighting Nuns," *Newsweek*, April 1, 1968, 100.

32 Kelley, n.p.

33 Opposed, were "fifty sisters, desiring to remain in canonical status, retaining the name (the California Institute of the Sisters of the Immaculate Heart) and organizational structure, which would adhere to the pre-

renewal practices." Margaret-Rose Welch, IHM, "Immaculate Heart Community," publication unknown. One of the fifty was Sister Mary Ruth, Corita's sister.

34 Corita Kent, "Art Is To Be Enjoyed," *The Lamp*, November 1965, 19.

35 "Helen Kelley does not recall whether Sister Mag entered it behind Corita's back or strongly urged her (under some well-meaning threat) to enter it." Correspondence between Sasha Carrera and the author, May 2006.

36 Bill Bagnall, "Corita at the De Cordova Museum / A Retrospective Exhibition," (Lincoln, MA: De Cordova Museum, 1980), brochure, n.p.

37 This reference to Sister Mag's strategy from correspondence with Jan Steward, June 2006.

38 Corita Kent and Jan Steward, *Learning by Heart: Teachings to Free the Creative Spirit*, (New York: Bantam Books, 1992), 40.

39 Kent, *Los Angeles Art Community: Group Portrait, Corita Kent*, 14.

40 The trajectories in Corita's prints and subsequent descriptions throughout this essay were ascertained from visual research done at the Grunwald Center for the Graphic Arts at the University of California at Los Angeles (UCLA), to which Corita donated examples of her serigraphs that amounted to over nine hundred prints as well as related drawings and sketchbooks, and, at the Corita Art Center at the Immaculate Heart Community (IHC), also in Los Angeles, which houses the inventory of prints, watercolors, and other printed matter that remained upon the artist's death. Corita bequeathed her inventory to the IHC along with her photographic archive and many papers and documents from the period in which she lived at the community and worked at the college. The Corita Art Center's website (www.corita.org) contains a database listing Corita's serigraphs and posters.

41 Kent and Steward, 184.

42 Peter Blake, *God's Own Junkyard: the Planned Deterioration of America's Landscape*, (New York: Holt, Rinehart & Winston, 1964).

43 Quoted in Woodward, 46.

44 Harvey Cox, *Commonweal*, October 24, 1986.

45 Sister Mary Corita, IHM, "Choose Life or Assign a Sign or Begin a Conversation," *The Living Light*, vol. 3, no. 1, spring 1966. n.p.

46 Ibid, n.p.

47 Many of these references are elaborated in the untitled booklet Corita published at the Immaculate Heart Community, 1966, n.p.

48 Loste, 108.

49 Sister M. Corita Kent, IHM, "art and beauty in the life of the sister," in Sister Mary Corita Kent, Harvey Cox, Samuel A. Eisenstein, *Sister Corita*

(Philadelphia / Boston: Pilgrim Press, 1968), 12.

50 Sister Mary Corita, IHM, "Choose Life or Assign a Sign or Begin a Conversation," n.p.

51 Bill Cunningham, "Nun Startles N.Y. With Her Graphic Art," in *Chicago Tribune*, December 29, 1965, Section 2.

52 Correspondence from Samuel Eisenstein to Elinor Jansz, May 2006.

53 Kent, *Los Angeles Art Community: Group Portrait, Corita Kent*, 90–91.

54 Kent, "art and beauty in the life of the sister," 15.

55 This first series Corita made outside of the IHC were transitional in that they shared certain attributes with previous prints, including fluorescent colors and political subject matter, yet used different graphic strategies. Notably, they were not printed by Corita herself, but sent to Hambley Studios in California, which from then on did all her printing. Mickey Myers commented, "As intense and mutually rewarding as that relationship was, something was lost in the immediacy of Corita's creative process. For those of us on the scene in both places – Los Angeles and Boston – it was a real relief to see her free from the arduous silkscreen process. But from that time on, her prints became something else." (Myers, in correspondence with the author, June 2006.)

56 Kent, "art and beauty in the life of the sister," 13.

57 Francine du Plessix Gray, *Divine Disobedience: Profiles in Catholic Radicalism* (New York: Vintage Books, 1971), 50. For more on the Catonsville event and the trial of the Catonsville Nine, see her chapter, The Berrigans, 45–228.

58 Mert Guswiler, "Corita Kent's 'Time Of Conversation,'" *Los Angeles Herald-Examiner*, March 14, 1971.

59 The college at large embodied collaboration in the form of team teaching a single course by as many as four professors from various departments.

60 Kent, *Los Angeles Art Community: Group Portrait, Corita Kent*, 20.

61 Ibid, 37.

62 See O'Garden and the interviews she conducted. I have not found hard-and-fast data on this subject, but the character of Sister Mag's and Corita's relationship and its conflicts have been alluded to and discussed informally on several occasions with people at the IHC. Jan Steward has also spoken about the subject, "Maggie wanted to continue as they had been for all those successful years. As Corita grew – older, experienced, aware – she wanted to change." Steward regarded their divergence as very sad, but also inevitable. Correspondence with the author, June 2006. Conflicts of this nature are easy to imagine between the two women, who were so closely associated and laboring under a host of pressures.

63 See O'Garden, n.p.

64 The Immaculate Heart College art department rules are published in Kent and Steward, 176, and in this volume, 46.

65 Kent, *Los Angeles Art Community: Group Portrait, Corita Kent*, 50.

66 Ibid, 98.

67 Ibid, 43–44.

68 Having worked collaboratively and in collective environments a great deal, I know from experience how in discussion or in the heat of activity, one thing leads to another. It is difficult retrospectively to trace the origin and path of a particular idea, suggestion, or decision from such contexts.

69 This phrase is from a Dash laundry detergent advertisement, and is the title of a print by Corita from 1967.

70 "Corita's handwriting became so recognizable that Hallmark cards developed it into a typeface called Corita for use in a series of its memento books…of which one was published. Corita learned about this after I discovered the book for sale in a Hallmark store in a mall. She had not been consulted in advance. After lengthy correspondence, Hallmark agreed to discontinue using the Corita typeface." Mickey Myers in correspondence with the author, June 2006.

71 Kent and Steward, 26.

72 Charles and Ray Eames were believers in using the camera's viewfinder as a looking device, and always kept a camera on every desk, though it was not necessary to have film in it.

73 Kent and Steward, 26.

74 Kent, *Los Angeles Art Community: Group Portrait, Corita Kent*, 88–89.

75 The slides Corita took during the years she lived at the Immaculate Heart Community are all kept there in her photographic archive.

76 Kent, *Los Angeles Art Community: Group Portrait, Corita Kent*, 45–46.

77 With the exception of *Immaculate Heart College, The Happy Ending* issue, published in 1980.

78 Corita Kent, *Footnotes and Headlines, a play–pray book* (New York: Herder and Herder, 1967).

79 Mary's Day is a day that honors Mary and usually takes place in early May, sometimes on May 1. It is not a specific date or feast day.

80 Kent and Steward, 178–81.

81 Ibid, 182.

82 Ibid, 186.

83 Kent, *Los Angeles Art Community: Group Portrait, Corita Kent*, 35.

84 Kent and Steward, 206.

85 Sandy Cutuli, "From Sister Mary Corita and the Art Department of Immaculate Heart College," *Our Sunday Visitor*, August 7, 1966.

86 Woodward, 46.

87 Kent, *Los Angeles Art Community: Group Portrait, Corita Kent*, 36.

88 Ellen Shulte, "Brotherhood Message in Christmas Packages," *Los Angeles Times*, November 26, 1965.

89 IBM commissioned the Eames office to make the film, *The Information Machine: Creative Man and the Data Processor* in 1957, which was shown at the IBM Corporation Pavilion at the 1958 Brussels World's Fair, and another film, *Introduction to Feedback* in 1960. In 1961 IBM commissioned the exhibition *Mathematica: A World of Numbers…and Beyond*, and the IBM Pavilion at the 1964–65 New York World's Fair contained several film projects that the Eames office made including the multiscreen presentation *Think*, 1962. Corita's slide archive contains many pictures of the Brussels fair and the New York fair, with many shots of Charles and Ray Eames among them, indicating that she spent time in the exhibits with them. It is possible that Charles Eames provided the initial link between Corita and IBM.

90 Shulte.

91 Cunningham.

92 Sister Mary Corita, IHM, "Choose Life or Assign a Sign or Begin a Conversation," n.p.

93 "All Quiet on Eastern Front as 'Peace on Earth' Reopens," *Los Angeles Times*, December 20, 1965.

94 Paul Page, "Changes in Nun's Art Display Disturb Communists – Not Her," *Northwestern Kansas Register*, January 14, 1966.

95 Paige Carlin, "Survival With Style," *Together*, March 1968.

96 "The titles of the classes were used to satisfy requirements from the state officials who sought to define what art was about. In my first class with Corita, Drawing, we had three hours to draw three inches of our own arm." Jan Steward, correspondence with the author, June 2006.

97 Cutuli.

98 Kent and Steward, 48.

99 Unattributed statement from Summaries of Practicums, in: Sister Mary Corita Kent, IHM, "Searching for the Creative Concept," *New Trends in Art Education* (The Catholic University of America Press, Inc., 1959).

100 Martha Monigle, "Sister Mary Corita: 'Be Aware! Be Curious! Be Joyous!'" *Alumni Review* (University of Southern California, September–October 1966), 4.

101 Kent and Steward, 48.

102 Ibid, 6.

103 Sister Mary Corita Kent, IHM, "Searching for the Creative Concept," *New Trends in Art Education*, The Catholic University of America Press, Inc., 1959, 60–62.

104 Kent, *Los Angeles Art Community: Group Portrait, Corita Kent*, 54.

105 Ibid, 181.

106 Ibid, 61–62.

107 Kent and Steward, 71.

108 Ibid, 112.

109 Ibid, 6.

110 See literature and webpage (www.selfhelpgraphics.com) of Self Help Graphics. "Self Help Graphics & Art has been the leading visual arts center serving the Los Angeles community for the past thirty years. Our mission is to: 1) Foster and encourage the empowerment of local Latino / Chicano artists; 2) Present Latino / Chicano art to all audiences through its programs and services; and 3) Promote the rich cultural heritage and contribution of Latino / Chicano art and artists to the contemporary American experience."

111 Kent and Steward, 6.

112 This motto was adopted from a saying in Balinese culture, according to Corita, as seen in Baylis Glascock's film, *Corita Kent: On Teaching and Celebration*.

113 Lorraine Wild, "Sister Corita Kent," *Subcultures. Rethinking Design Number Five: The Visual Language of Subcultures* (Mohawk Paper Mills, Inc., 1999), 29.

114 Mike Kelley has said that "my artistic model for the felt banners was Sister Mary Corita" and "Corita Kent, psychedelic posters, left-wing graphics, and underground comics were the first things I saw and thought of as art." Mike Kelley interviewed by John Miller, *Mike Kelley* (New York: A.R.T. Press, 1992), 33, 36.

115 Unattributed flyer of Corita's accomplishments, distributed by the IHC.

116 Rothon, 11.

117 Galm, 149.

118 Mickey Myers, correspondence with the author, June 2006.

119 See Daniel Berrigan, "The Colors of Corita Kent," in this volume, 114.

Acknowledgments

I am thankful to Martin Beck for our dialogue and long shared passion for Corita's work, which have consequences throughout this book. Appreciation is due Nils Norman and Alex Farquharson for their preliminary discussions with Elinor Jansz, which helped bring us into contact.

I am grateful to Daniel Berrigan for his stellar text that contributes substantial insight into Corita, her artistry, and the times they shared. I heartily thank Josh White for the care, expertise, and generosity he extended in photographing Corita's serigraphs for this publication.

I am indebted to all those who have permitted their words and images to be reproduced here. Special thanks are due Daniel Berrigan, Samuel A. Eisenstein, Baylis Glascock, John C. Goodwin, David Goodwin, Gerald Huckaby, Helen Kelley, Mickey Myers, Maurice Ouellet, and Jan Steward for mining their archives and memories. For editorial input, inspiring engagement, and other fortification, I thank Cynthia Burlingham, Lenore Dowling, Mary Anne Karia, Peggy Kayser, Helen Kelley, Annette Kosak, Andrea Miller-Keller, Irene O'Garden, Ann Philbin, Jason Simon, and Wolfgang Tillmans.

It has been an enormous honor to work with Elinor Jansz and Four Corners Books. Elinor's profound engagement throughout the process of making this volume, as well as her openness and consummate attention to detail, have made for a wonderful collaboration. Likewise, Richard Embray has provided astute input throughout the process of shaping the book, in addition to exceptional editing.

Elinor and I extend deep thanks to Nick Bell and Hélène Samson of Nick Bell Design for the inspired design and nuanced formulation of the book's visual and material realization. Simon Appleton has expertly printed this book with considerable skill and care. In this regard, appreciation is also due Martin Lee for his invaluable and wise production advice. We are grateful to Alan Williams for providing copyright counsel.

We are immensely indebted to the Corita Art Center and the Immaculate Heart Community for access to Corita's art, papers, and photographic archive, and for allowing Corita's serigraphs and photographs to be published here. Throughout the research and preparation of this volume, Sasha Carrera, director of the Corita Art Center, has provided every form of support possible.

My experiences visiting the IHC were infused with Corita's presence. Her prints hang on every wall; she is frequently spoken about and her creative principles are referenced by many of the women I met there. Those encounters were invariably informative and stimulating.

This book is dedicated to my friend, Jim Hodges, who first pointed me in the direction of Corita.
J.A.

Contributors

Julie Ault is an artist who independently and collaboratively organizes exhibitions and multiform projects. Her practice emphasizes interrelationships between cultural production and politics. Exhibitions include *Information*, in collaboration with Martin Beck, at Storefront for Art and Architecture, New York, 2006, and *Power Up: Sister Corita and Donald Moffett, Interlocking*, at the UCLA Hammer Museum, Los Angeles, 2000. Ault is the editor of *Alternative Art New York, 1965-1985* and *Felix Gonzalez-Torres*. She was a cofounder of the artists' collaborative Group Material, active from 1979 to 1996.

Nick Bell Design is an independent, multi-disciplinary graphic design consultancy based in London. Their approach to visual communication is driven by a close attention to context. Nick Bell, their director, was creative director of *Eye*, the highly influential international review of graphic design, from 1997 to 2005. His experience on *Eye* enabled him to develop a more curatorial method of editorial design – one his studio has adapted very successfully for the design of exhibitions. Clients have included the V&A, the Science Museum, Tate, the British Council, National Portrait Gallery and the new award-winning Churchill Museum in London.

Born in Minnesota in 1921, **Daniel Berrigan** is a Jesuit priest, poet, and peace activist who has been nominated many times for the Nobel Peace Prize and is a recipient of the Thomas Merton and the Pacem in Terris awards. He has written over fifty books including *The Bride: Images of the Church* and *Uncommon Prayer*. A member of the Catonsville Nine and Plowshares Eight, Daniel Berrigan continues to demonstrate against war and nuclear weapons and give lectures across the country about the scriptures and the call to peacemaking. He lives at the West Side Jesuit Community in New York City.

Established by Elinor Jansz in 2003, **Four Corners Books** is an independent publisher based in London, specializing in books by artists and books about art. Publishers Jansz and Richard Embray work closely with artists and curators, tailoring each book to the individual needs of the project. Already published are: *An Architecture Of Play* by Nils Norman and *Brian Wilson: An Art Book* edited by Alex Farquharson.

About this book

Some of Sister Corita's prints included in this book (specifically many of those between pages 65 and 96) include fluorescent colors that are impossible to reproduce in the standard 4-color printing process. As the inks that Corita used were made from different substances and applied repeatedly using a hand held squeegee, rather than a mechanical press, it is not possible to mimic them precisely. However, by using day-glo inks where appropriate and thanks to the expertise of our printers the colors reproduced here are a good likeness to the original serigraphs. A comparison between the reproductions of *E eye love* on pages 26 and 80 gives an indication of the difference between traditional 4-color reproduction and that using fluorescent ink.

This book has been typeset using Century ATF Schoolbook BQ and Akzidenz Grotesk BQ from the H. Berthold AG typefoundry.

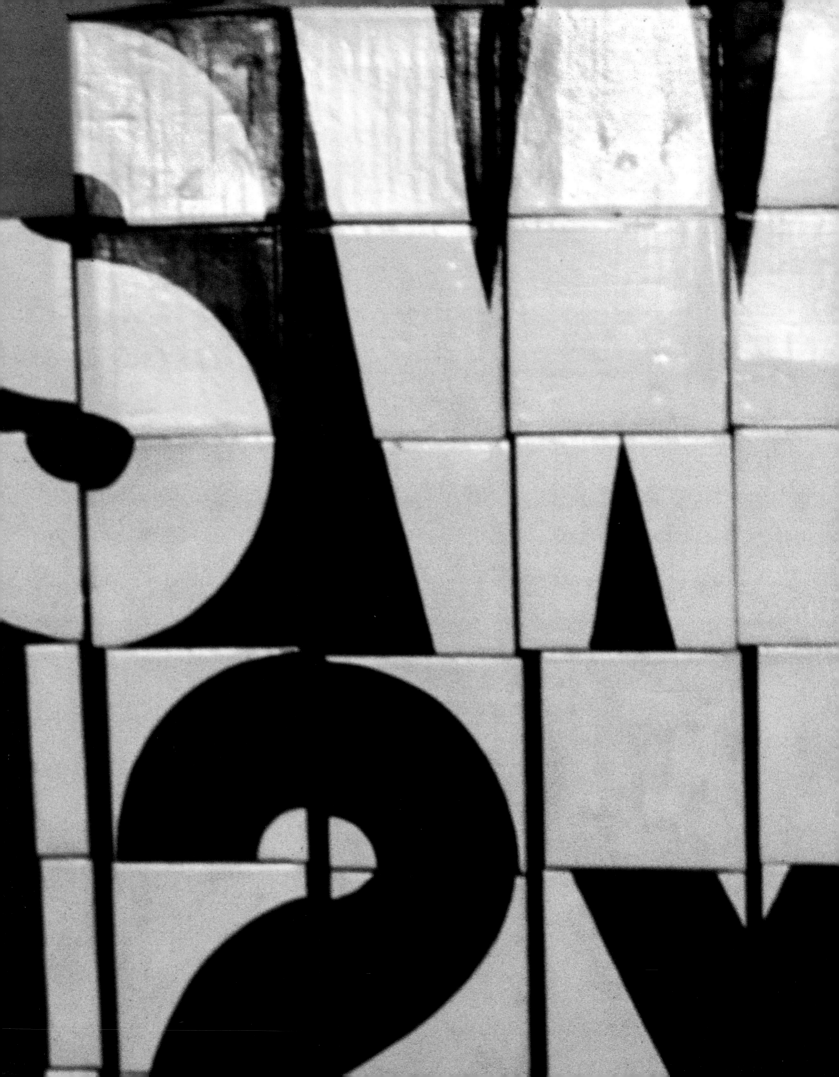

Index

The page numbers of illustrations and reproductions are marked in *italics*.